CW00540580

# LEICESTER IN 50 BUILDINGS

## STEPHEN BUTT

AMBERLEY

First published 2016

Amberley Publishing, The Hill, Stroud
Gloucestershire GL5 4EP

www.amberley-books.com

British Library Cataloguing in Publication Data.
A catalogue record for this book is available from the British Library.

ISBN 978 1 4456 5920 6 (print)
ISBN 978 1 4456 5921 3 (ebook)

Origination by Amberley Publishing.
Printed in Great Britain.

# Contents

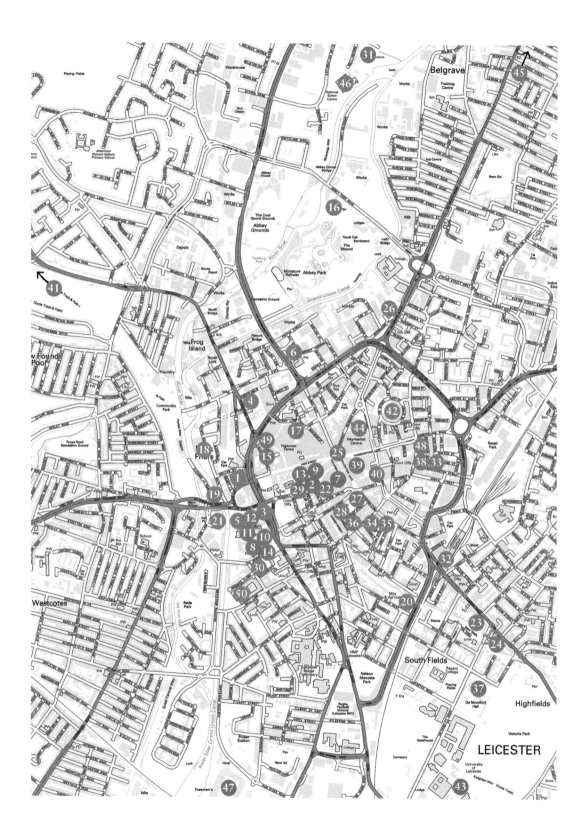

# Introduction

Until recent years, Leicester has hidden much of its long and rich history. Some of its finest buildings are tucked away from the main streets. These could be easily missed by visitors if not for the descriptive information panels that Leicester City Council introduced in the wake of the worldwide interest surrounding the discovery of the remains of Richard III. Leicester has always lacked an architectural focal point, such as a building of grand design and stature, or a city square that marks its centre. Instead, it has its Victorian clock tower, which although much loved by residents, could have been built much taller. Even Leicester's dignified and finely proportioned town hall is a modest, understated building, facing a quiet, leafy square away from the bustle of the main shopping streets and is easily overlooked.

Leicester's secrets are worth discovering. Stand anywhere in the city and there is a fascinating history just a few inches away. Highlights include the very impressive Jewry Wall and the remains of the Roman baths, the charming but modest cathedral church of St Martin, the Norman undercroft hidden beneath the modern BBC studios and the castle guarding the River Soar. The Heritage Centre of De Montfort University in the solid red-brick Hawthorn Building is home to arches from the lost Church of St Mary of the Annunciation in the Newarke, in the shadows of which the body of Richard III rested in state before being buried in the nearby friary.

In the eighteenth century, the Industrial Revolution reached Leicester, and the town changed forever. Wolsey Knitwear can trace its origins back to 1748 when two local hosiers, Henry Wood and Job Middleton, went into partnership. A century later, Leicester was home to many of the country's greatest names in textile manufacturing, for example, Nathaniel Corah, Thomas Kempton and Faire Brothers; this also included companies dealing in dying, spinning and weaving, and in machine tools from Bentley engineering, Stibbe, Wildt Mellor Bromley and British United Shoe Machinery.

Today, the remnants of those industries can be seen throughout the city. Although many of the old factories and mills have been demolished, a surprising number have survived and found a new role in twenty-first-century Leicester.

Leicester has so much to live for. It deserves to be discovered and is worth a second glance. By exploring beyond the central shopping area, off the beaten track, and along the lanes that meander towards the line of the medieval walls, its true heritage is revealed. The city's long history is written in its buildings, some of which reflect the recent past and others that reach back 2,000 years.

# The 50 Buildings

## 1. Jewry Wall and Roman Baths, c. AD 125

The purpose and nature of Leicester's oldest standing structure, and the largest Roman building outside London, was not fully understood until excavations by the pioneering archaeologist Kathleen Kenyon between 1936 and 1939. It was taken into state care in 1920 but was largely disregarded until the adjacent archaeological remains were discovered after a factory on the site was demolished.

The purpose of the structures has been a matter of much debate. Antiquarian historians saw it as a Roman or British temple, perhaps dedicated to the god Janus. Others identified it as part of a bathing complex. In the nineteenth century, it was seen as one of the town's gates or as part of the town basilica.

Kenyon first believed that the site was part of the Roman forum. She later changed her opinion, suggesting that the earlier forum had been rebuilt as baths. Later archaeological research undertaken between 1961 and 1972 confirmed that the forum site was to the east, near to Jubilee Square. The Jewry Wall was then seen as the wall of a gymnasium, which would have been part of the baths complex, but this is not accepted by all.

The name of the wall is also a mystery. It was known by its present name as early as the seventeenth century. One theory is that it relates to Leicester's medieval Jewish community, who were expelled from the town in 1231 by Simon de Montfort. Another suggestion is that it is connected to the jurats of early medieval Leicester, who formed the senior 'cabinet' of the corporation and met in the town churchyard, possibly that of St Nicholas' Church. The word is from the same root as 'juror', meaning someone who has taken an oath to

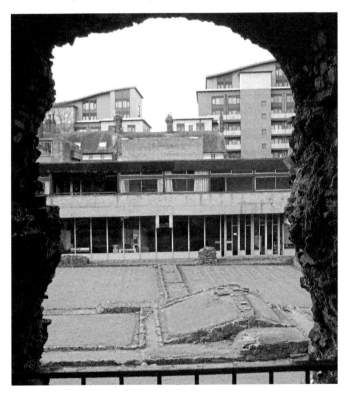

Brutalist structures: the Jewry Wall Museum viewed through an arch of the Roman Jewry Wall.

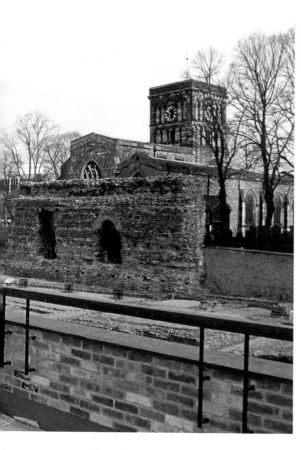

*Left*: The Jewry Wall with the parish church of St Nicholas.

*Below*: The Jewry Wall Museum viewed across the site of the Roman baths complex.

perform a certain duty of judgement. The antiquarian William Stukeley used this name and accepted this definition for his map of Leicester published in 1772.

It is now generally agreed that 'jewry' represents a broader folk belief across Europe that tended to attribute the origin of any mysterious structure to the Jewish people.

## 2. Leicester Cathedral, 1086

The parish church of St Martin's became Leicester's cathedral in 1927. It has been one of the principal churches in the town for more than 700 years and the 'civic' church since the sixteenth century.

In 1927, the appointment of Dr Cyril Bardsley as Bishop of Leicester was a significant event in the ecclesiastical history of the town, effectively recreating the bishopric after almost 1,000 years. It is said that Cuthwine, Leicester's first bishop, was appointed in AD 679. The last of these early bishops was Ceobred, who was consecrated between 839 and 840 and died between 869 and 888, after which Danish incursions led to the seat being transferred to Dorchester-on-Thames in Oxfordshire. The location of the first cathedral in Leicester is not known but it was likely to have been the nearby parish church of St Nicholas.

A Victorian tradition asserted that St Martin's was built on the site of a temple dedicated to Diana, the goddess of the hunt, the moon and childbirth. In 1784, large quantity of cattle bones were unearthed beneath the building while a grave was being dug between the nave and the chancel.

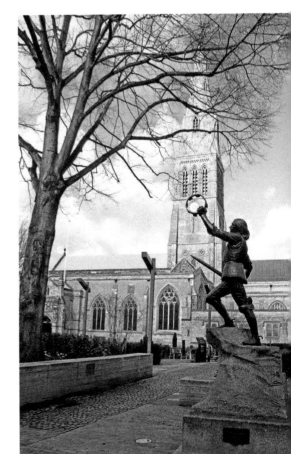

The former king's crown aligns with Leicester Cathedral's clock face.

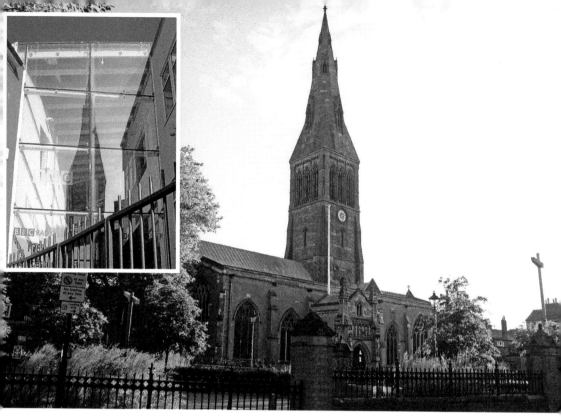

Leicester Cathedral from the site of the former Wyggeston's Hospital. *Inset*: The spire of Leicester Cathedral framed by the atrium of the BBC's St Nicholas Place studios.

The Guild of Corpus Christi was founded in 1343 as a social and religious guild attached to St Martin's Church, and the church itself was enlarged by the addition of a great south aisle to accommodate a dedicated chapel.

The Vaughan Porch on the south side of the church was built in 1897 in memory of Edward Vaughan and his sons, all of whom gave much to the town, and three of whom – Charles, Edward and David – followed in their father's footsteps to become successive vicars of the church. The family name lives on in Vaughan Way, part of the central ring road.

The reinterment of Richard III in 2015 has given this modest cathedral a prominent place on the world stage, with tourists visiting from great distances. After much turmoil, both during his lifetime and after his remains were discovered, the simple tomb that marks the king's final resting place is already a place of modern pilgrimage.

## 3. St Mary de Castro, 1107

The parish church of St Mary de Castro was the chapel of the castle and stands within its precincts. 'Castro' was added to differentiate it from Leicester Abbey, otherwise known as St Mary de Pratis. The history of this ancient and beautiful church is closely linked to the men who occupied the castle and to their visitors. It is said to have been founded in 1107 as a collegiate church with a dean and twelve canons, and as a chantry chapel for the family of Robert de Beaumont and the first three Norman kings of England.

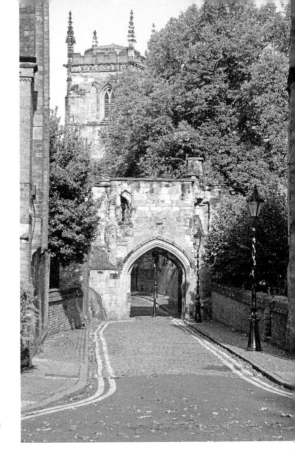

The tower of St Mary de Castro rises behind the Turret Gateway leading from the Newarke.

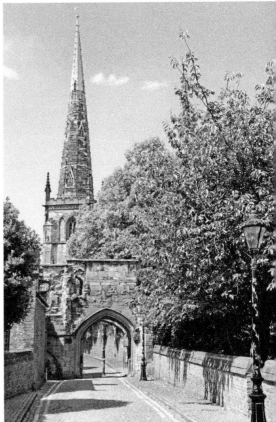

The same view before the demolition of St Mary de Castro's fine spire.

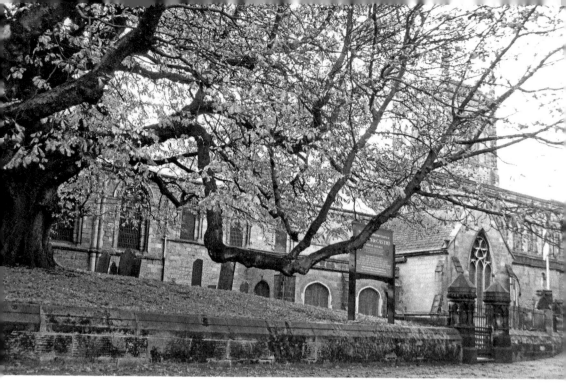

St Mary de Castro as seen from Castle Street.

There is a popular claim that it was here that Geoffrey Chaucer married Philippa de Roet, a lady-in-waiting to Edward III's queen, Philippa of Hainault, and a sister of Katherine Swynford, who would become John of Gaunt's third wife. In 1426, Henry VI was knighted here, as an infant, when the famous Parliament of Bats was taking place inside the castle. At this time, tensions between the Duke of Gloucester, the young king's uncle, and Cardinal Beaufort led to concerns that violence could break out during the parliament. It was therefore decided that weapons would not be permitted within the great hall of the castle. However, some of the attending barons concealed clubs or 'bats' beneath their outer clothing.

The fine fourteenth-century slender spire, which had to be rebuilt in 1783, was removed in 2013 because it was unsafe. The dangerous condition caused the church and the surrounding area to be closed for several months. Ironically, it was Victorian repairs that were the principal cause of its near-collapse.

St Mary de Castro is still an active place of worship but describes its community as 'a traditional Anglo-Catholic church under the Episcopal oversight of the Bishop of Richborough, the Right Revd Norman Banks'. The position of Bishop of Richborough, termed an 'episcopal visitor', was created in 1995 to administer to congregations who, in good conscience, could not accept the ministry of clergy who were involved in the ordination of women. He works under the authority of the Archbishop of Canterbury.

## 4. All Saints Church, 1143

Six churches are recorded in Leicester in the Domesday Book of 1086 and it is assumed that All Saints was one of these. In 1143, it was given to Leicester Abbey and, the tower, the

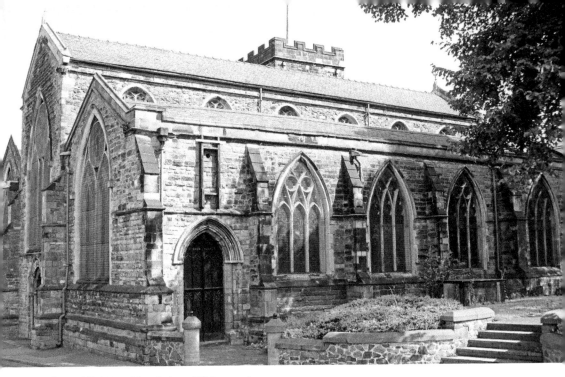

*Above*: All Saints Church from Highcross Street.

*Below left*: The Jacobean clock above the south door of All Saints Church.

*Below right*: All Saints Church from the quiet and leafy churchyard.

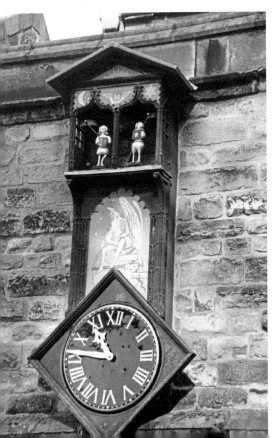

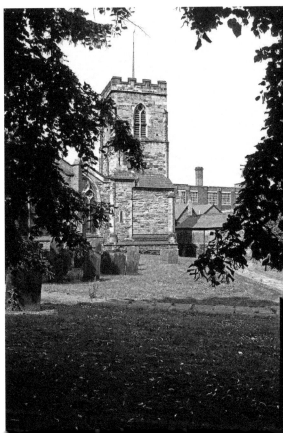

nave and new aisle roofs were built in the following century. In 1583, during outbreaks of the plague, the assizes were held in the church.

After years of neglect, the chancel was rebuilt in 1829. Local architect Henry Goddard installed new seating and extended the gallery in 1843, and later restored the roof. Further restoration took place some decades later and the tower was restored by William Basset-Smith in 1894–95.

In the 1960s, the central ring road was constructed, which isolated the church from the centre of the city. The congregation declined and the chancel was divided from the rest of the church to form a smaller place of worship. The church closed in 1982 and was declared redundant on 1 January 1983. It was handed over to the Churches Conservation Trust on 8 July 1986. However, the Highcross shopping centre has brought new life to this area. The John Lewis car park now overlooks the churchyard and the table tomb of Gabriel Newton, the local politician and founder of the Alderman Newton's (or 'Bluecoat') School, who died in 1762.

One of the most interesting elements of this ancient building is the clock, which dates to the time of James I. It was taken down from the front of the church in 1875 for repairs and restoration. In 1900, it was installed in its present position above the south door. The clock consists of a dial, above which is a panel painted with allegorical representations of Time with his scythe. At the top of the timepiece are arches, through which two carved 'jacks', each about 1 foot in height and dressed in Jacobean costume, emerge to strike the quarters. The present figures are replacements, the originals having been stolen in the early 1970s. In 2009, the clock was again fully refurbished without charge by the Leicestershire and Rutland Freemasons.

## 5. Leicester Castle, 1150

Despite its present-day appearance and its seventeenth-century exterior, Leicester's castle was probably built only a few years after the Norman Conquest, which suggests that plans for its construction were drawn up almost as soon as the invaders reached Leicester.

The first structure was a wooden bailey on a motte, which has survived and is accessible by a footpath. Today, it is not easy to appreciate that this fortification, standing on earlier Roman structures, effectively guarded the southern and western approaches to Leicester, making use of the river as a form of moat.

The great hall has one of only three Norman arched ceilings in Britain and dates from 1150. It was built by Robert de Bossu, 2nd Earl of Leicester and is the oldest aisled and bay-divided hall in Europe. John of Gaunt lived here and among his visitors was a young Richard II, who returned years later as a prisoner before his deposition by Gaunt's son, Henry IV. The exterior was built in 1695 as a family mansion and, in the nineteenth century, the building was converted again to become the assizes.

In his book *Leicester Castle* (1859), the nineteenth-century Leicester historian James Thompson commented that 'it was more than a baronial mansion – it was the Palace of the Midlands during the most splendid period of the Middle Ages'. However, Thompson was writing in an era that romanticised the past rather than treating it with respect. He was of the opinion that the motte existed much earlier than the conquest, and that the underground building, part of the castle structure known as John of

Leicester Castle dominating the approach to the town from the River Soar. *Inset*: Renovation work being carried out on Leicester Castle in 2015.

Gaunt's cellar, was the castle's dungeon. Such opinions have not withstood the test of modern scholarship.

Until the 1960s, the picturesque gardens that are laid out beneath the castle along the bank of the River Soar were a corporation rubbish tip. They now form part of a much longer network of towpaths and walks that connect the city with the suburbs. The castle is now part of De Montfort University's extended campus and accommodates its business school.

## 6. St Margaret's Church, 1200

Now standing by the side of St Margaret's Way, a modern dual carriageway and the ancient Churchgate, this is a stately and dignified church of impressive proportions that has one of the finest perpendicular towers in Leicestershire.

Although St Margaret's is one of the historic churches of Leicester, it is actually located outside of the medieval walls of the city at the extreme north-east corner of the old town. It is the only Leicester parish church not to have been in the gift of Leicester Abbey, instead being under the jurisdiction of the Diocese of Lincoln.

The present church is the third church to stand on this site. The first was a Saxon church, which was established in AD 679. It was after the Danish invasions of the ninth century that jurisdiction passed to Lincoln. A significant programme of rebuilding took place in the thirteenth century and the tower and clerestory were added in 1444. The oldest work in the church can be seen at the east end of the north aisle, where an excavated area is exposed to show the foundations and a well from the first building. In the chancel is the alabaster tomb of Bishop Penny, a former abbot of Leicester.

The west end of the church faces Sanvey Gate, which follows the line of the northern town wall. 'Sanvey' is thought to be a corruption of '*Sancta Via*', meaning the Holy Way. The road gained this name because a procession took place between St Mary de Castro Church and St Margaret's Church every Whit Monday.

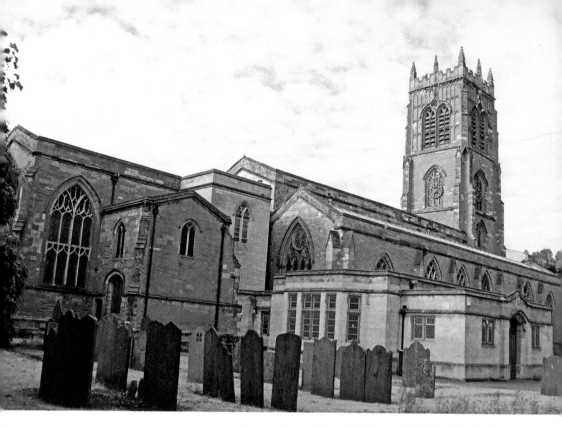

*Above*: St Margaret's Parish Church: the church outside the town walls.

*Left*: St Margaret's Parish Church: the East End and the churchyard.

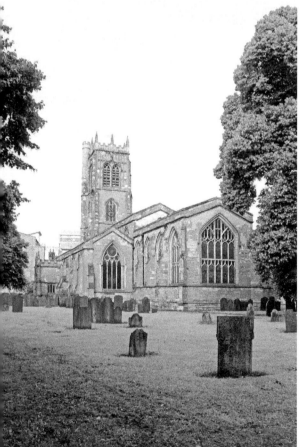

The impressive south door of St Margaret's Parish Church.

After the closure of the nearby Nathaniel Corah textile factory, the statue of St Margaret, which had been used as the Corah emblem for many years, was rescued and reinstalled in front of the church of her dedication. St Margaret was a shepherdess, hence her association with wool. The emblem was patented by the company on the very first day of the 1875 Trade Marks Registration Act and is therefore the oldest trademark for knitted goods in the world.

## 7. Leicester Market, 1298

Behind the façades of the shops fronting Gallowtree Gate, connected by the 'jitties' or alleys between those premises, Leicester Market is still the vibrant heart of Leicester's retail experience after many centuries of trading. The jitties mark points of access once breached in the old town walls when merchants would follow the turnpike from Market Harborough to arrive in Gallowtree Gate, wishing to trade their wares in the market inside.

Leicester has had numerous markets in its long history, and today's street names provide some clues: Holy Bones may be Leicester's 'shambles' where the butchers traded; Horsefair Street is self-explanatory; and the High Cross was, unsurprisingly, another point at which trading and bartering took place. There was another market in Redcross Street, formerly the 'Reed Cross', but that has now been lost in redevelopment.

Surviving wars, winds, redevelopment and numerous other threats to its existence, Leicester Market in today's Market Place has been trading for more than 700 years. The colourful and diverse stalls of today tell a fascinating history. The first known royal grant dates to 1229, although the traders mark their anniversaries from a document of 1298.

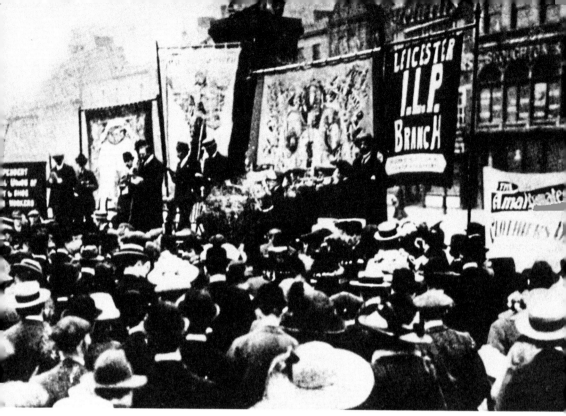

*Above*: A political rally in Leicester's Market Place in the nineteenth century.

*Below*: A colourful image of Leicester Market from the Edwardian era.

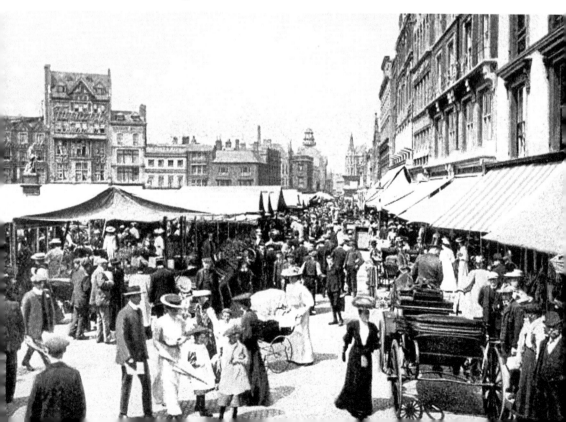

A market for the twenty-first century: part of the new indoor market.

Far more recently, the present market roof was 'opened' by veteran entertainer Bruce Forsyth in 1992 and a permanent café was added in 2002.

The latest chapter in its history began recently with the demolition of the former indoor market, which is now being replaced by a modern structure that still respects the heritage of the area.

## 8. Trinity Hospital, 1330

In 1330, Henry Plantagenet, 3rd Earl of Leicester and Lancaster, commissioned a hospital to treat the poor and the infirm of the town. It was built on land next to the castle precincts. Originally called the Hospital of the Honour of God and the Glorious Virgin and All Saints, it became Trinity Hospital in 1614. The building was reconstructed in 1776 and again in 1901, but the original medieval chapel has survived.

The hospital had room for fifty poor and infirm people, of whom twenty were permanent residents. There was also accommodation for four chaplains and five female nurses. The chaplains were supposed to 'avoid taverns and the market place', and the nurses were to be of 'good fame and untarnished reputation'. However, in the centuries that followed, there were repeated accusations of malpractice.

The building was probably damaged during the Civil War when the Royalists defeated the Parliamentarians in Leicester, the fiercest fighting being in the Newarke, but the gravest threat to its existence came with the post-Industrial Revolution expansion of Leicester.

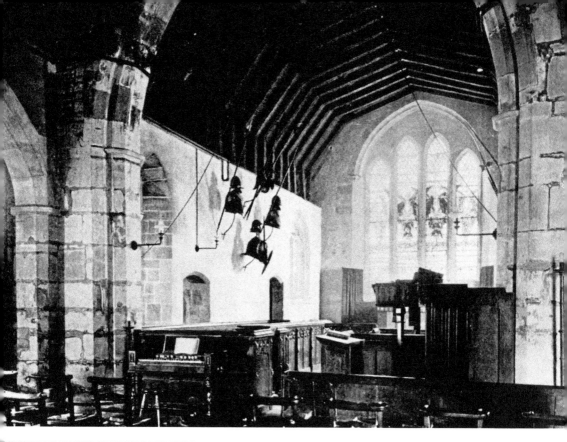

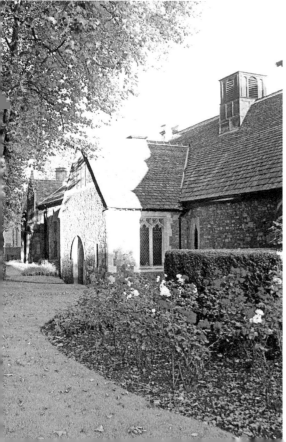

*Above*: The interior of Trinity Chapel, photographed in the 1920s when still in use as a hospital.

*Left*: The serene façade of Trinity House, formerly Trinity Hospital, in the Newarke.

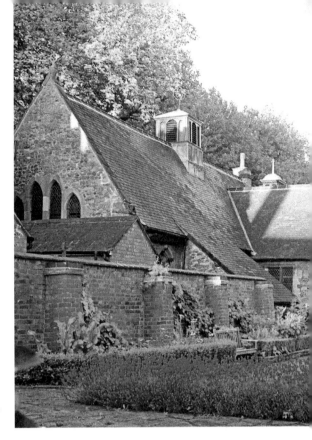

Trinity House Chapel, the oldest part of the original hospital buildings.

In the final years of the nineteenth century, the corporation announced plans to demolish the hospital to make way for a new road and bridge connecting the town with the Newarke and the expanding West End. In the wake of one of Leicester's earliest conservation campaigns, a compromise plan was adopted. The medieval chapel at the eastern end of the building was saved, but the rest of the hospital was demolished and rebuilt at an angle.

Today, the modern Trinity Hospital is a sheltered housing scheme in a modern building on the canal bank at the junction of Duns Lane and Western Boulevard. It retains its royal connections to the Crown through the Duchy of Lancaster. The old building is now in the ownership of De Montfort University and houses part of the university's administrative offices. Music is still performed from time to time in the chapel.

## 9. The Guildhall, 1390

The earliest part of the Guildhall was built around 1390 as the meeting place of the Guild of Corpus Christi, a group of businessmen and gentry who had religious associations and had been founded in 1343. The building also accommodated a chantry priest who would pray for the souls of guild members in the adjacent St Martin's Church.

Many of the members of the guild were also part of the civic leadership of the town, and gradually these two activities and roles increasingly overlapped. By the end of the fifteenth century, the town council was holding all of its meetings in the Guildhall and when the Dissolution of the Chantries Act was introduced in 1563, the council purchased the building and used it as the town hall until 1876.

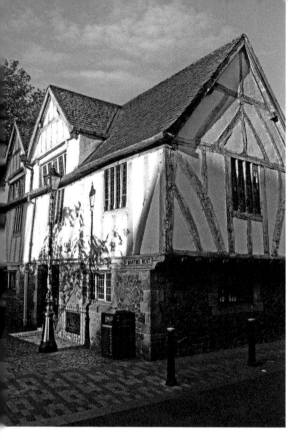

*Left*: The Guildhall. This wing was used as Leicester's first police station.

*Below*: A close-up of the light and shadows of the Guildhall viewed from St Martin's West.

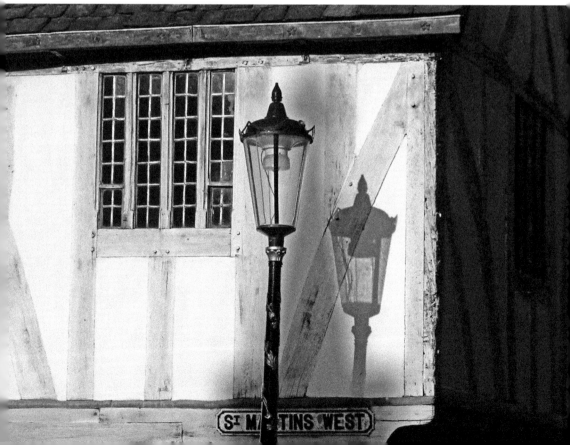

The Guildhall became Leicester's first police station in 1836 after the Leicester Borough Force had been set up in the previous year. The building also houses the third oldest public library in England, which was established in 1632 in the east wing of the building. The books in the collection include the New Testament in Greek, dating from the fifteenth century, and most are still on display today.

The fabric of the building, with its several wings, staircases and balconies, reflect the different periods in its history and the activities that were carried out here. This includes the construction of quarters for the chief constable in 1840, which were later used as cells.

By the beginning of the twentieth century, the building had fallen into disrepair. Its demolition was proposed, but after the intervention of the Leicestershire Archaeological and Historical Society, the council began restoration work on the building, finishing it in 1926 when the Guildhall was opened as a museum.

It is also said to be the city's most haunted building with no fewer than five ghosts having been seen and identified. Today, the Guildhall houses the Medieval Leicester Galleries; it was here in the great hall that the formal announcement was made that the remains discovered beneath the nearby Greyfriars were indeed those of Richard III.

## 10. Newarke Gateway, 1410

The Newarke or Magazine Gateway is still an imposing structure despite being surrounded by taller modern buildings. It was built as the main entrance to the Newarke precinct around 1400 with the intention of impressing visitors and local people rather than having a defensive role. The exterior was heavily restored in the nineteenth century.

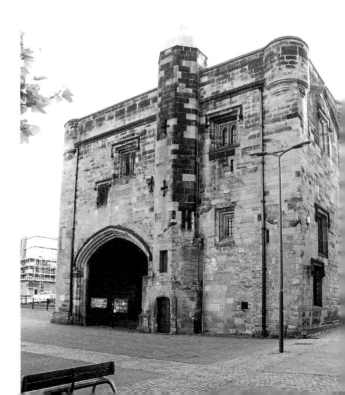

The Newarke or Magazine gateway was designed to impress, not as a means of defence.

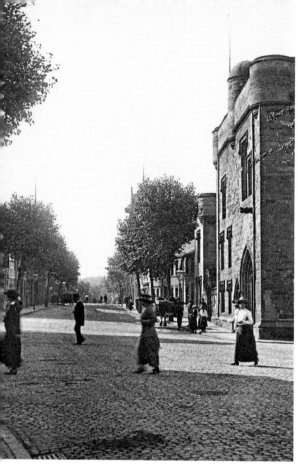

*Left*: Oxford Street and the Newarke
Gateway before the era of the internal
combustion engine.

*Below*: The Newarke Gateway, now flanked
by university buildings dedicated to Hugh
Aston and Edith Murphy.

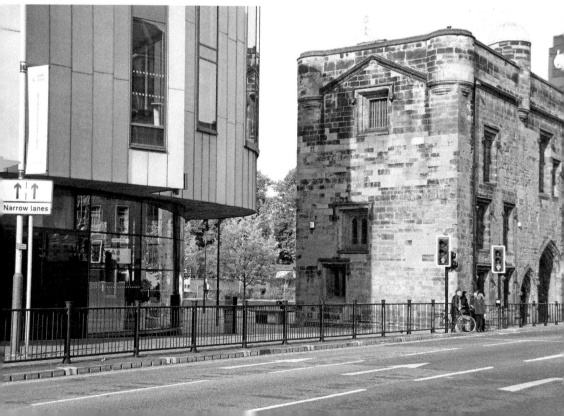

It acquired the name 'Magazine Gateway' during the Civil War when it was used for the storage of the town's weapons and gunpowder. This military association continued with the construction of Territorial Army barracks on part of what is now known as Magazine Square. In the twentieth century, it also housed a museum collection dedicated to the history of the Leicestershire Regiment. This closed in the 1990s because the ancient staircase was deemed unsafe.

Leicester's central ring road system was originally laid out either side of the Newarke Gateway, leaving it stranded between lanes of traffic and accessible only by subways and steps. The road was subsequently rerouted and the Newarke subway filled in. In 2012, Queen Elizabeth II became the first monarch for many centuries to pass through the gateway when she visited De Montfort University during her jubilee year.

## 11. Turret Gateway, 1422

The Turret Gateway, dating to the same period as the Newarke Gateway, was the second entrance into the Newarke and connects the precinct with the castle. Part of the original medieval walls can be seen in the nearby gardens of the Newarke Houses Museum forming the boundary of the churchyard of St Mary de Castro.

In 1645, Prince Rupert led a fierce attack on Leicester during the Civil War with an army five times greater than the Parliamentarian force protecting the town. This area of the Newarke saw much fierce fighting, beginning on 30 May when the walls were breached.

Black Annis, Leicester's famous witch, is said to inhabit the gateway at night.

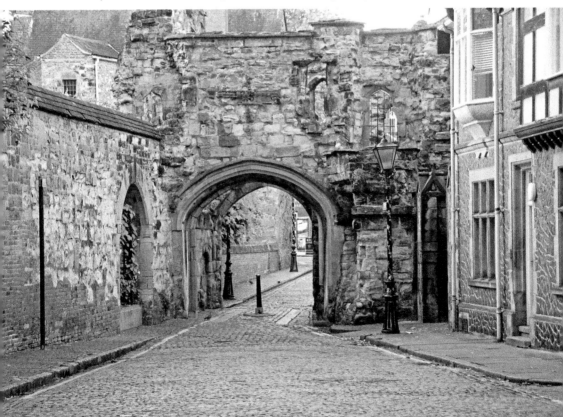

Until the nineteenth century, there was a gap in the nearby wall known as 'Rupert's Gateway' a name that has also been erroneously applied to the Turret Gateway.

Leicester's famous witch, Black Annis, is said to lurk in the shadows of the gateway, using underground tunnels to enter the town from her cave on the other side of the River Soar. It is said she pounces on those who dare pass through the gateway at midnight.

## 12. Castle House, Judge's Lodgings, 1445

A timbered gatehouse, dating from 1445, links St Mary de Castro with Castle House, which is actually two linked medieval houses and a further building dating to the Georgian period. Together, these structures formed, in part, the lodge of the porter guarding the entrance to the Castle Yard.

The earliest clear reference to the house dates to 1633 when Charles I authorised William Heyrick to sell a quantity of the material from the then ruinous castle to help pay for the repair of Castle House. Evidence of human burials were discovered during refurbishment work around 1750, suggesting that the site was either part of the burial ground of St Mary de Castro or possibly a place where the bodies of those executed on Castle Green were interred.

The name 'Judge's Lodgings' refers to its role for many years in accommodating Her Majesty's High Court judges when visiting the city. The building is still used for some civil events organised by Leicestershire County Council (who own the house) and for accommodating official guests. However, in 2016 discussions took place to find a new role for this attractive building, perhaps as a public banqueting facility.

The impressive entrance to Castle House, which has been used by senior judiciaries for centuries.

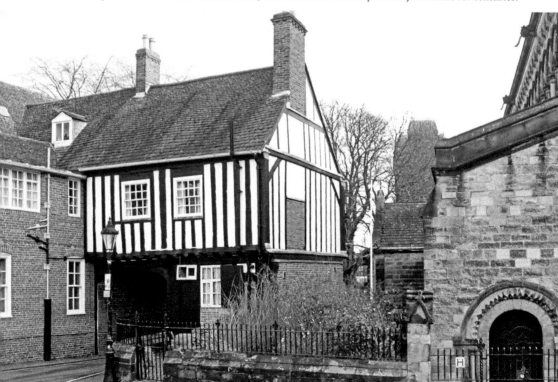

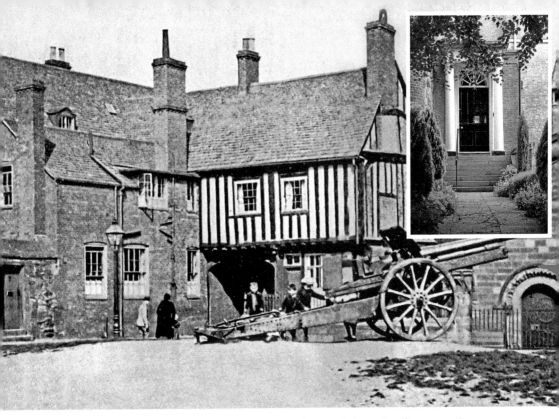

A similar view dating to the late nineteenth century, emphasising Leicester's military past. *Inset:* Castle House, the judge's lodgings, viewed from Castle Green.

## 13. Wygston's House, 1490

In medieval times, Highcross Street was where many of Leicester's wealthiest citizens lived. Wygston's House on Applegate by the side of the modern Jubilee Square is a fine example of the kind of high-status residences built and occupied by these successful and wealthy men and their families.

It is generally agreed that this was the house of Roger Wygston (which is how he spelled his name in his will), who was Mayor of Leicester on three occasions between 1465 and 1487. Wygston also served as the MP for Leicester in 1473 and 1488 and died in 1507. His initials could be seen in ten of the twenty-nine panels of stained glass dating to 1490 that were in the north-facing windows of the house until they were removed in 1824.

Roger Wygston was probably an uncle of the more well-known William Wyggeston who is commemorated on the clock tower for his philanthropic work. Wygston's House has survived partly because it was protected by a later building that fronts Highcross Street.

The family name continues to the present day in Wyggeston's Hospital and Wyggeston and Queen Elizabeth I College, which are bodies that stem from foundations set up with money accrued by William Wyggeston in his role as a wool merchant.

Wygston's House is owned by Leicester City Council and has been used for a variety of purposes since it ceased to be a residence. It was the city's costume museum for many years, before being leased to several community groups and organisations. After remaining empty for nearly a decade, in 2015 Leicester City Council announced that it was again

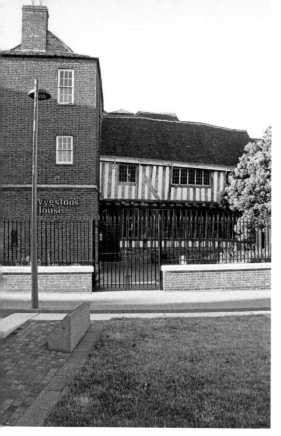

Wygston's House was protected by the erection of the later adjoining Georgian house.

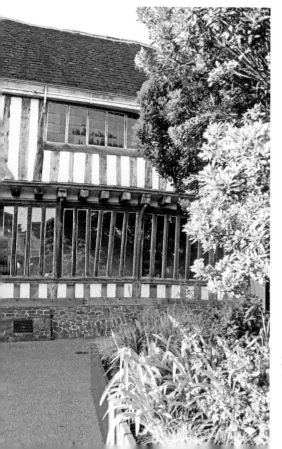

Empty for some years, agreement was reached in 2016 for conversion to a restaurant.

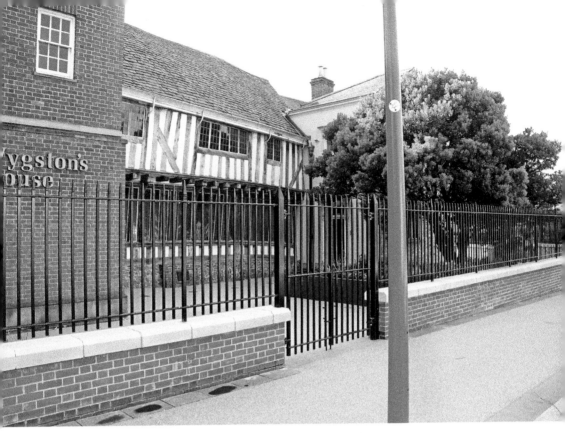

The recent Jubilee Square has given Wygston's House a new visual setting.

willing to lease the building and invited proposals to give it a new purpose and provide an opportunity for the public to have access. In January 2016, it was announced that a lease had been agreed with a company that would use the building as a bar and restaurant, serving an English menu, and which was willing to work with local heritage groups to protect this amazing building and the home of one of Leicester's important citizens.

## 14. Chantry House, 1511

Presently housing the museum of social history, Wygston's Chantry House and its neighbour Skeffington House now overlook Magazine Square and De Montfort University's buildings from two different eras: the Hawthorn Building and the Hugh Aston Building.

Chantry House is one of the most notable buildings in the Newarke. Construction began in 1511 to provide accommodation for the chantry priests, who were paid by William Wyggeston to say prayers in the collegiate church of St Mary of the Annunciation in the Newarke. It was added to in the centuries following the Reformation and finally acquired by a private trust in 1912. The trust also purchased the neighbouring Skeffington House, which dates from about the end of the sixteenth century. Chantry House was badly damaged during the Second World War but was restored between 1953 and 1956. Both buildings were passed to the Leicester Corporation for use as a museum.

There are pleasant and secluded gardens behind the museum, where there is also the only remaining fragment of the original Newarke boundary wall separating the gardens

The Wyggeston Chantry House, part of the Newarke Houses Museum.

from the churchyard of St Mary de Castro. Nearby is the herb garden of the former Trinity Hospital. Surprisingly, although the gardens evoke an air of ancient tranquillity, in the nineteenth and early twentieth centuries a large corn mill rising to a height of four storeys stood here. This was also where mason and sculptor Joseph Herbert Morcom worked his stone and created his statues including that of Cardinal Wolsey in Abbey Park and the Liberty Statue near the Upperton Road Bridge over the river. The Elgood Iron Foundry was also in this area and this is probably where the ornate gates of Leicester's railway station façade in London Road were made. Two of the Elgood sons, George and Thomas, became distinguished topographical artists, and one of Thomas's surviving watercolours is of the Newarke with a view towards Skeffington House.

## 15. The Elizabethan or Free Grammar School, 1573

This early educational foundation was established by Thomas Wyggeston, brother of William, and Agnes, his widow, after William's death in 1536. Stone from the nearby derelict church of St Peter's, which had previously accommodated a small school, was used in its construction. The new building was much needed as records indicate that, by 1572, most of the roof and timbers of St Peter's had been removed, except for the area of the south aisle where the school was housed. Elizabeth I gave a donation to the new school, and this gift no doubt encouraged Leicester's wealthiest citizens to follow suit. A list of the benefactors is incorporated into the wall of the building. The structure was founded by the queen in 1564 and completed in 1574.

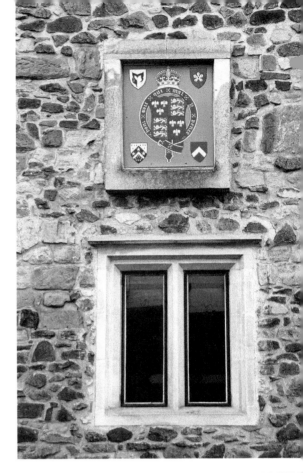

The arms of the principal benefactors of the Elizabethan Grammar School.

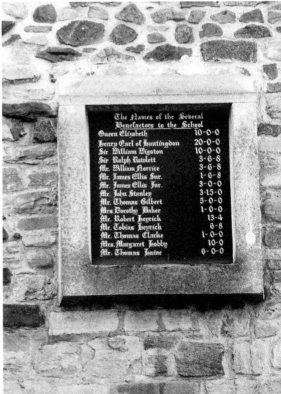

The Elizabethan Grammar School benefactors and Wyggeston matched Queen Elizabeth's donation.

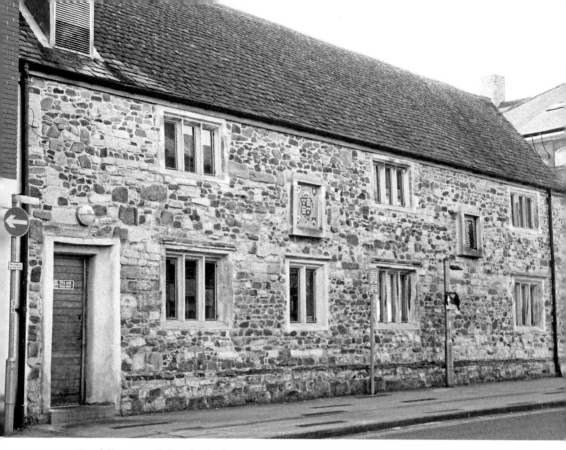

Carefully restored, the Elizabethan Grammar School is now a restaurant and bar.

It continued as a place of education until 1841. It was then used by a variety of different businesses, including a joiner's shop and a warehouse and as the local offices of the former Barton Bus Company, but this building of great character has now been carefully restored and accommodates a restaurant as part of the Highcross Shopping Centre. Further stone from St Peter's, rediscovered in archaeological investigations before the shopping centre was constructed, was used during its refurbishment.

## 16. Cavendish House and Abbey Park, 1613

It is only a short distance from the centre of the city, but Abbey Park seems to be a world away from the hustle and bustle of modern life. Although, like many municipal parks, it was a Victorian creation, the land has a much longer history that reaches back to 1143 when Robert de Bossu, 2nd Earl of Leicester, founded the Abbey of St Mary de Pratis in the Augustinian tradition, and dedicated it to the Assumption of the Virgin Mary.

It was here that one of Leicester's most important historical accounts was written, by the librarian of the abbey, Henry of Knighton. He wrote of contemporary events between 1377 and 1395 as well as providing a historical record of the period between 1066 and 1366. Knighton offers a remarkably favourable account of John of Gaunt and describes the impact of John Wycliffe who, under Gaunt's patronage and protection, became rector of Lutterworth in Leicestershire. Knighton also provides important material about how the

*Above*: Cavendish House was largely built from material removed from nearby Leicester Abbey.

*Right*: The ruins of Cavendish House in Leicester's Abbey Park.

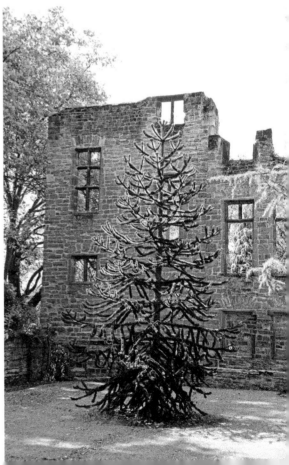

Charred stonework is evidence of the fire of Cavendish House in the Civil War period.

Black Death affected the town, including the impact on the price of food, grain, wine, wages and the availability of labour, and the sad statistic that almost one third of the inhabitants of Leicester died of the plague that struck so devastatingly in 1348/9.

At the Dissolution, the abbey and its lands were granted to the Marquess of Northampton who later sold it to William Cavendish, 1st Earl of Devonshire. In the seventeenth century, he built a substantial house nearby using stone removed from the ruins. The house was later used by Charles I in 1645 during the Civil War and was deliberately gutted and set on fire by his forces after his departure. The charred ruins remain today.

The abbey ruins contain a memorial to Cardinal Thomas Wolsey, who was buried in the grounds. He died on 29 November 1530 while travelling from York to London. A statue stands near to the park's café by the local nineteenth-century stonemason Joseph Morcom.

Little remains of the abbey today but its approximate 'footprint' is marked within the grounds. In recent years, much more knowledge of the abbey has been gained following archaeological digs, which have been used to train students at the University of Leicester.

Plans to convert the 57 acres into a public park began in 1879, when the corporation commenced wider flood alleviation work along the whole stretch of the River Soar. The work involved widening and deepening the river for a length of 1 mile, the excavated soil being used to landscape the parkland with mounds. Stone weirs and locks, and three new bridges, were also constructed. More than 33,000 new trees were planted and an artificial lake was created. It was opened by the Prince and Princess of Wales on 29 May 1882, and extended in 1932.

The park has been the venue for many major public events. An annual flower show developed into the larger City of Leicester Show, which ran from the 1940s until 1980s, and this was also the site of the famous Leicester Pageant of 1932. Part of the original abbey boundary walls are still in existence bordering the modern St Margaret's Way, named after a former abbot of the abbey, John Penny. A small section of the same wall was repaired at some stage using stone retrieved from the Greyfriars church.

Takeover Radio, run by and serving the young people of Leicester, has its studios and offices in one of the gatehouses guarding the main entrance from Abbey Park Road.

For some years, as was the case with municipal parks throughout the UK, Abbey Park suffered from lack of investment. Greenhouses were allowed to fall into disrepair and the ornate flower borders were grassed over. Today, there is a new interest in our green open spaces, which are regarded as important amenities. Abbey Park is once again in good condition and well maintained. It is a valuable asset to the city and appreciated by many hundreds of residents and visitors every day.

## 17. Great Meeting, 1708

Amid the hard landscaping of modern Leicester, a short walk from the centre of the shopping area and in the shadow of Leicester' largest shopping precinct, is this remarkable building surrounded by leafy trees that provide a real sense of peace. For those who have little or no interest in religion, the message here is to take time to appreciate Great Meeting and to discover how it has changed Leicester.

Some 300 years of 'freedom, reason and tolerance' are represented and celebrated by this very special Leicester building, the home of the Leicester Unitarians. It was built in 1708 and claims to be the oldest complete-brick building in the city. It is certainly one of the most important historic buildings still serving the purpose for which it was constructed.

The history of the building, and those who have worshipped within it, dates back even further to the early followers of the Presbyterian sect who, in 1680, were given a licence to meet in a barn near to the present site of the Leicester Royal Infirmary. Presbyterians were those who disliked the formalities and traditions of the Anglican Church but who believed that it was better to stay and try to change attitudes from within rather than to break away.

Two years later, the early Congregationalists were known to be meeting in another barn near Millstone Lane. It is possible that this building was a remnant of the Greyfriars complex, and it is recorded that the early Methodists in Leicester also gathered here. They came to share the same minister, and in a short time became united in their beliefs. As the congregation grew, a permanent church was needed, and the Great Meeting Unitarian Chapel was planned, and opened in 1708. The form of worship in the church became Unitarian at the beginning of the nineteenth century, and its members were a very strong influence on the political and civic life for more many years, even to the present day.

In essence, Unitarianism is a Christian denomination that takes an open-minded and individualistic approach to religion, and so allows for a very wide range of beliefs and interpretations. Everyone is free to search for meaning in life in a responsible way and to reach their own conclusions. This belief counters many non-conformist denominations, which believe in some degree of exclusivity. As its name implies, it believes in the concept of monotheism but not that of the Trinity (as in, God the Father, God the Son and God the Holy Spirit).

*Left*: The Great Meeting. A building of dignified simplicity and great charm.

*Below*: The former schoolrooms of the Great Meeting.

Unitarians want religion to be broad, inclusive, and tolerant. Unitarianism can therefore include people who are Christian, Jewish, Buddhist, pagan and atheist. Today, there are about 7,000 Unitarians in the UK, served by about 150 ministers. The Great Meeting here in Leicester is still very much part of the city and merges successfully into the surrounding businesses, welcoming shoppers and workers without qualification.

In 1835, the Municipal Reform Act paved the way for a dramatic change in how Leicester was governed. The 'old guard' of the previous corporation was rejected, making way for a group of enlightened and responsible leaders, many of whom came from the ranks of the Unitarians, and were industrialists, businessmen, entrepreneurs, and benefactors. Even today, the Great Meeting's influence is maintained. A recent Lord Mayor, Councillor Manjula Sood, worshipped at both her Hindu temple and at Great Meeting. Sir Peter Soulsby, the elected Mayor of Leicester since 2011, is a senior Unitarian, serving on the Executive Committee of the General Assembly of Unitarian and Free Christian Churches, acting as its convenor, thus continuing an important and valuable association.

## 18. Friars Mill, 1739

Known locally for many years as the Domisthorpe Mill, Friars Mill on Bath Lane is Leicester's oldest surviving factory building. As the city's dominance in textile manufacture developed, many of Leicester's finest factory buildings were constructed in this area around Bath Lane. In 1960, the architectural historian Nikolaus Pevsner described Friars Mill as 'a brick building of seven bays and three storeys, with a three-bay pediment and a pretty clock turret, still entirely Georgian in style'.

The riverside view of the renovated Friars Mill.

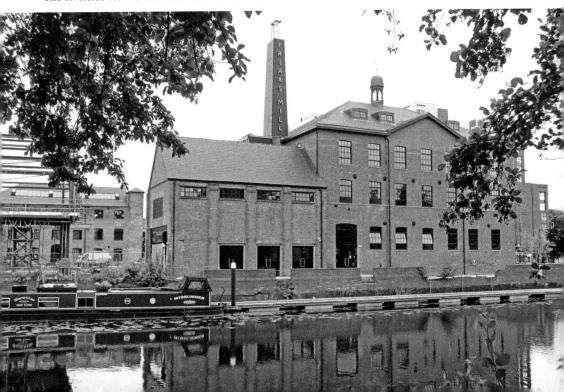

The complex closed in 2005 and suffered several years of neglect, which led to decay and further damage to its structure. In 2012, it was badly damaged by fire. The building was subsequently purchased by Leicester City Council for £550,000 and a remarkable rebuilding and refurbishment plan was put in place and cost £6.3 million, including £3.9 million of European funding.

The completion of the project, which has included the former Pump House and the adjacent Bath Lane Mill, was marked by the return of the factory's distinctive cupola. At the top is a decorative ibex that has been handcrafted to reflect the factory's original weathervane. The mill's new chimney has been refabricated in zinc and features bold Friars Mill lettering that is illuminated at night. The final stages of the refurbishment were filmed by BBC television for its series *Hairy Builders*, featuring 'hairy biker' David Myers.

Donisthorpe & Co. was founded in 1739, but the name of the mill stems from the Black Friars of the Order of St Dominic who occupied the land beside the River Soar from about 1220. The earliest records of the company date to 1866 when Alfred Russell Donisthorpe was spinning yarn on the premises. In the twentieth century, the company narrowed its market and, by the 1930s, F. W. Woolworth was the only company it supplied. Donsithorpe were taken over by the French company DMC in 1988 and in 2001 became part of the Amaan group.

The Friars Mill buildings now provide accommodation for fifteen small-to-medium-sized businesses, and is working as a catalyst for the further regeneration of the waterside area north of West Bridge.

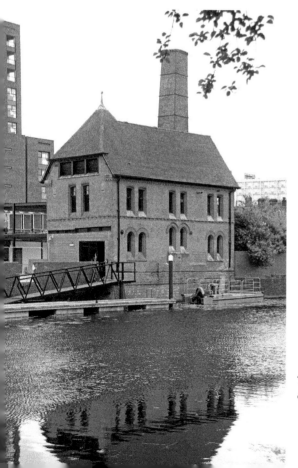

The former Pump House of the Friars Mill complex.

## 19. West Bridge Railway Station, 1832

Leicester was one of the first English railway towns. George Stephenson opened his Stockton to Darlington line in 1825 and the Liverpool and Manchester Railway in 1830. By then, he and his son, Robert, were in discussion with landowners and engineers in Leicestershire about constructing a line between the coalfields of North West Leicestershire and Leicester. Discussions with local businessmen took place at the famous Bell Hotel in Humberstone Gate and resulted in the opening of the Leicester to Swannington Railway just two years later on 17 July 1832.

The line was needed to bring coal into the town and onwards to the major residential and industrial areas. The Leicestershire pits were competing with those in Nottinghamshire that had the benefit of a canal network. Carrying such a heavy commodity by road was difficult, as for many months of the year the carts found the heavy clay of Leicestershire unable to bear the weight.

The Leicester terminus of the line was beside the wharf at West Bridge where coal could be transferred to the River Soar navigation. Today, the area is dominated by the road traffic system of St Nicholas Circle around the Holiday Inn. The canal is still evident and some Victorian factories and mills have survived. The remnants of that first railway terminus can still be seen, close by the canal near to Tudor Road and King Richard III Road, but it is now an inauspicious memorial to a great engineering achievement, neglected and marred by vandalism and graffiti. The original platform still survives and the track bed is a public footpath.

The terminus was rebuilt several times and initially was not intended for passenger use. Not until 1893 were facilities such as platforms provided. The local investors in the line acquired several useful buildings, including some rural inns, along the route that were brought into use as ticket offices and waiting rooms. The early travellers were required to purchase their fare at one of these buildings and the 'ticket' was a metal token, handed in at the destination.

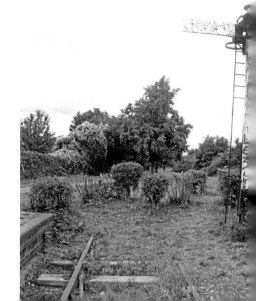

Remnants of Leicester's first railway station near West Bridge.

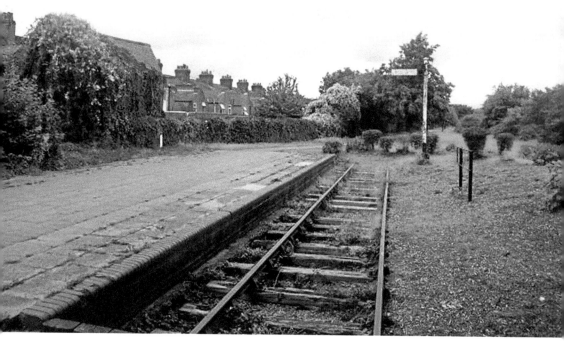

Part of the platform is original. The track bed is now a public footpath.

## 20. New Walk Museum, 1836

Leicester was one of the first towns in England to establish a municipal museum. This splendid building, designed by Joseph Hansom of Hinckley (inventor of the Hansom Cab) was built as a proprietary school and was purchased by the corporation in 1846. It opened to the public in 1849, the contents of the private Literary and Philosophical Society library having been transferred to it from the old Liberal Hall. However, it was not until 1860 that a curator was appointed, a move that triggered a period of expansion and development.

At first, there was a heavy dependence upon natural history, and although visitors would be presented with rows of cases of stuffed birds, there was some attempt at an early stage to present artefacts in context using pictorial displays, a precursor to today's 'hands-on' experiences. Part of the ground floor was devoted to 'local antiquities' including Roman artefacts. The building also houses Leicester's collection of art, with a number of representative pieces being displayed in the Victorian Gallery. Since the museum opened, this impressive room has been the headquarters of the Literary and Philosophical Society and has also been used for small-scale music recitals.

The rooms beyond the Victorian Gallery to the south, and the vestibules that connect them, which are also used for exhibitions of art and for meetings of the Leicestershire Archaeological and Historical Society, were added later and were used in the twentieth century as offices of the lord mayor.

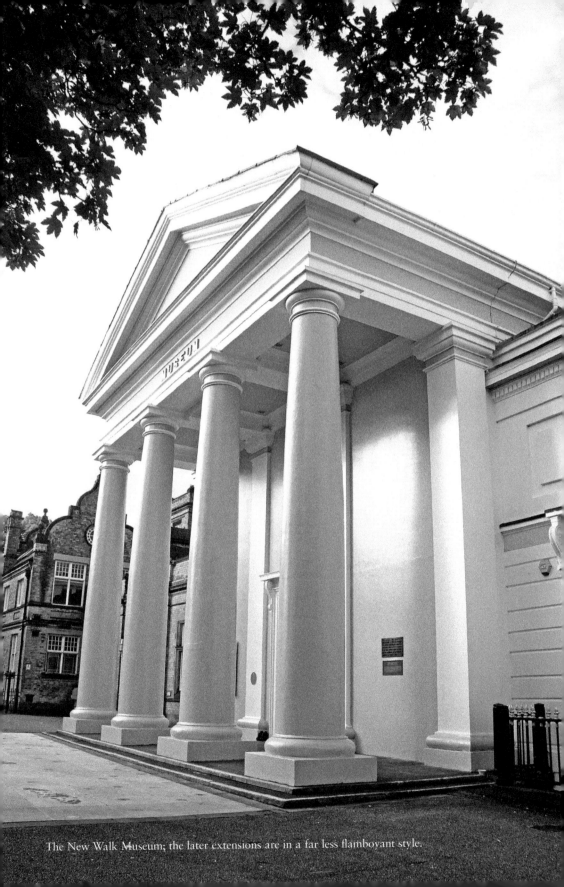

The New Walk Museum; the later extensions are in a far less flamboyant style.

Sir David Attenborough, who attended the Wyggeston Boys' School in Leicester, was a frequent visitor to this museum and was inspired by what he saw as a young boy. The Dinosaur Gallery, reorganised in 2011, was reopened by Sir David. New Walk also holds an impressive Picasso collection donated by the late Lord Attenborough.

The museum is associated with two other distinguished experts in natural history: explorer, geographer, anthropologist and biologist Alfred Russel Wallace and entomologist Henry Bates. Wallace briefly taught drawing, map-making and surveying at the Collegiate School in nearby College Street. He is best known for having developed a theory of evolution independent of Charles Darwin, his research papers having been presented jointly with Darwin's.

Henry Walter Bates was born in Leicester in 1825. He provided the first scientific account of mimicry in animals. With Wallace, he explored the rainforests of the Amazon. Although Wallace returned to England early, Bates remained in the area for eleven years. During this time, he sent back over 14,712 species (mostly of insects), 8,000 of which were new to science. A plaque at the entrance to the museum commemorates the work of these two remarkable men whose modest dispositions have led to their achievements being understated, if not forgotten. Bates in particular, though probably lesser-known than his colleague and friend, is remembered for his discovery of a trait in animal behaviour which has become known as Batesian Mimicry, describing the process in evolution where a harmless species has evolved to imitate the warning signals of a harmful species directed at a common predator.

A modern dual carriageway cuts through this area today, forming part of the central ring road and appropriately named Tigers Way, as it connects the Leicester Tigers Rugby Ground on Welford Road with the railway station on London Road. The road runs under New Walk and a tarmac footway links the railway station with the museum, providing a pedestrian route down into the city.

The museum also commemorates two important naturalists, Henry Bates and Alfred Russel Wallace.

HENRY WALTER BATES. F.R.S., 1825 - 1892
AND
ALFRED RUSSEL WALLACE. F.R.S., 1823 - 1913

THESE TWO VICTORIAN NATURALISTS, FRIENDS OF CHARLES DARWIN, HAVE STRONG ASSOCIATIONS WITH THIS PART OF LEICESTER. BATES WAS BORN A HUNDRED YARDS OR SO FROM THE SITE OF THIS MUSEUM, AND MET WALLACE WHEN THE LATTER WAS TEACHING AT THE COLLEGIATE SCHOOL JUST OFF THE LONDON ROAD. IN 1844 - 1846, THE TWO JOINED FORCES IN AN EXPEDITION TO THE AMAZON. IN 1849, WALLACE RETURNING IN 1852 & BATES IN 1859, THE YEAR IN WHICH DARWIN'S "ORIGIN OF SPECIES" WAS PUBLISHED. IN 1858 WALLACE DISCOVERED, INDEPENDENTLY OF DARWIN, THE PRINCIPLE OF NATURAL SELECTION AS A KEY FACTOR IN EVOLUTION. BATES, ON THE AMAZON, DISCOVERED OVER EIGHT THOUSAND NEW SPECIES OF ANIMALS, MOSTLY INSECTS, AND GAVE THE FIRST EXPLANATION OF WHAT IS NOW KNOWN AS BATESIAN MIMICRY.

## 21. Westbridge Place, 1844

This Grade II-listed building was designed by local architect William Flint in 1844 for J. Whitmore & Sons, who were worsted spinners. By 1888, it had become known as Westbridge Mills because of its proximity to the ancient West Bridge crossing of the river.

At five storeys in height, it was built to dominate the local skyline and to demonstrate the economic power and dominance of the textile industry in Leicester. It has a grand slate pitched roof, an Italianate bell tower with three arched openings and an ornate weather vane.

Whitmore's became a branch of Patons and Baldwins Ltd, famous manufacturers of knitting yarn, and was known under that name until 1936. In 1949, H. T. H. Peck acquired part of the building, but shared the site with Patons and Baldwins and the Leicester College of Art. It was still used as a worsted spinning mill, but later as a factory manufacturing socks and tights, particularly after the entire building passed into the hands of Pex in the early 1970s.

In 1979, a fire gutted the front parts of the building, and eighteen fire appliances attended the blaze, which could be seen from many areas of the city.

The building was fully refurbished in the 1990s when the glass extensions and front lift shaft were added to the building. In 1994, Leicester City Challenge made this building the centre of regeneration for the area. Architects HLM and Loughborough-based builders William Davis Ltd were able to integrate the building into earlier work along the canal.

Westbridge Place: the glass staircases provide light and allow the original fine brickwork to be revealed.

*Above*: Every element of this former spinning mill has been carefully renovated.

*Below*: Westbridge Place, an example of the wealth and vibrancy of Leicester's former textile industry.

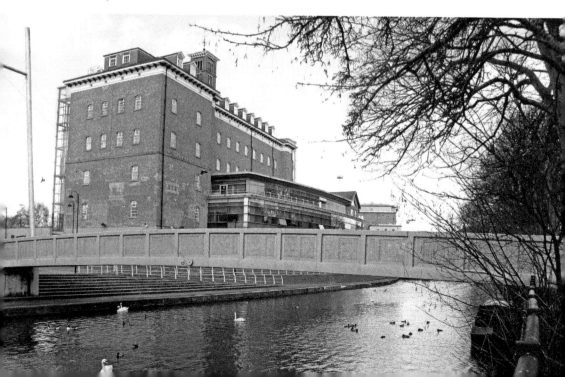

The glass extensions on the front and rear were designed to reveal the original building and to provide extra space and light. The outside of the building was intended to have the appearance of a steam liner when viewed from the bridge. The cost of the refurbishment was in the region of £4.25 million. Only Friars Mill and Westbridge Place remain of the twenty-six mills listed in the Leicester directory of 1826. It is currently occupied by the Land Registry.

## 22. The Corn Exchange, 1850

Between around 1850 and 1880, the character of Leicester's landscape changed dramatically with the construction of a significant number of iconic buildings, which over the years have become such familiar landmarks that they are almost 'invisible' to today's shoppers and visitors. Of these, the Corn Exchange in the Market Place stands out as a building of quality and dignity, yet one that for several decades has suffered from neglect at a time when almost all things Victorian were despised. A corn exchange was a building where farmers and merchants traded cereal grains and they were in English towns and cities until the late nineteenth century.

Leicester's market is not in the centre of the city. The city has seen many markets in its long history, which for a variety of reasons gradually combined and ultimately created today's busy Leicester Market – this is actually in the far south-east corner of the medieval walled town.

Until the last century, markets were mainly temporary structures that were erected only on preordained market days, but there have been permanent buildings on the site of the Corn Exchange since the fifteenth century, providing accommodation for butchers and clothiers. An earlier building, completed in 1509 and known as the Gainsborough, stood on this site. It was used partly as a gaol and law courts and partly as shops, and had a dungeon in the cellar. It suffered considerable damage during the Civil War in 1645 but it was not until 1748 that it was replaced by another structure, which became known as 'the exchange.'

Today, this splendid successor to the first exchange is a busy and welcoming place which, for the first time in its life, is being surrounded by sympathetic modern developments of good quality. Now Grade II-listed, it was built in by the Leicester architect William Flint, but the upper floor with the impressive external stone staircase was added by F. W. Ordish some years later in 1856. This addition was the result of a competition held by the corporation. Ordish's winning design also included the clock tower, which gives even more height to the structure. It was well ahead of its time, so much so that many Leicester people instantly disliked it because of the 'shock of the new'. This reaction may explain why, in future decades, the council decided to extend the roofing of the adjacent market in a way that all but concealed the Corn Exchange from view.

The dance hall on the top floor of the building was once popular with American soldiers and their admirers stationed in the city during the Second World War, but fell into disrepair in the 1960s following a serious fire that gutted part of the upper storey.

The City Council still owns the building and this has provided the authority with an opportunity to include it in a far-reaching twenty-first century development of the entire market area. This has seen the first stage of the new indoor market in 2015, costing over

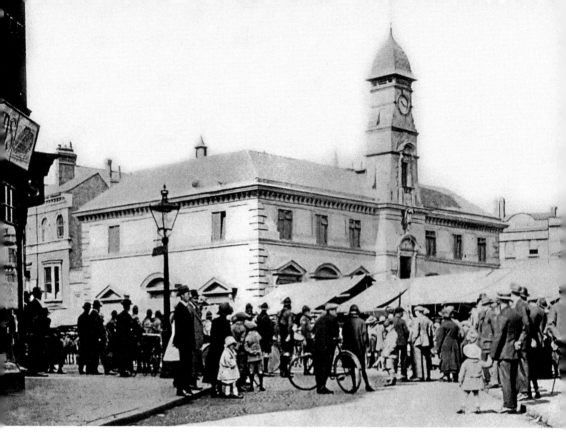

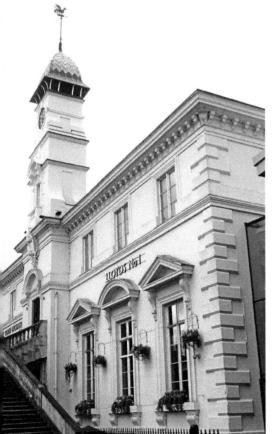

*Above*: The Corn Exchange seen from Market Approach before the first permanent market roof was constructed.

*Left*: The Corn Exchange – at the heart of Leicester's Market Place since 1850.

£4 million. Designed by architects Grieg & Stephenson, it is lightly connected to the Corn Exchange by a glazed roof. The second stage, approved in 2015 with a budget of over £9 million, involved the demolition of the old indoor market building, which will be replaced by an extension to include a bar and restaurant area, giving access to the old ballroom on the upper floor of the exchange.

## 23. Top Hat Terrace, 1864

Built in 1864 on the western side of London Road, above and opposite Devonshire Place, is the Top Hat Terrace. It was originally known as Victoria Terrace. It acquired its unusual name because of the sixteen stone heads along the front of the building. The nickname is from the top hats worn by the police until 1872, but all sixteen of the effigies on this façade represent a certain Detective Inspector Francis 'Tanky' Smith in his various disguises.

Tanky Smith was the first detective to be appointed when the Leicester police force was formed in 1836. Together with a second detective, Tommy Haynes, Tanky is credited with considerably reducing the amount of petty crime in the town. He became a master of disguise and successfully infiltrated criminal gangs to secure incriminating evidence.

When he finally retired as a police officer, Smith became a private detective. His most well-known assignment took place when he was hired by the Winstanley family of Braunstone Hall to find James Beaumont Winstanley, who had disappeared while touring in

Top Hat Terrace: the intricate detail above the front doors.

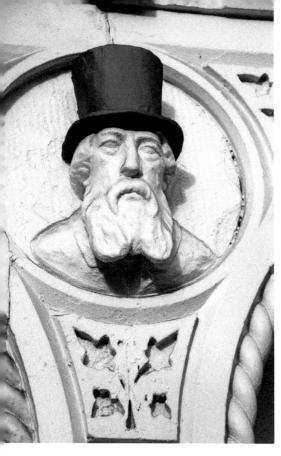

*Left*: Tanky Smith, a great Leicester character immortalised in stone.

*Below*: The splendid Top Hat Terrace commemorating Leicester's first 'private eye'.

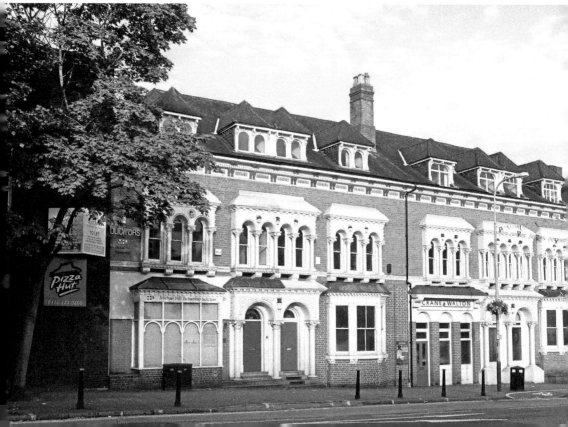

Europe. Tanky was handsomely rewarded for his efforts and invested his money in building Victoria Terrace on London Road, as well as developing Francis Street in Stoneygate.

Top Hat Terrace was designed by Tanky's son, James Frances Smith, as a tribute to his famous father. The terrace was refurbished in 1987 thanks to a grant of £7,700 from Leicester City Council and remains a fine compliment to an unusual and remarkable man.

## 24. Victoria Road Church, 1866

University Road, running from Welford Road past the university campus to London Road, was in its earliest days called Occupation Road, and then known as Victoria Road.

On the junction with London Road is a remarkable place of worship. It represents a kind of Victorian experiment in ecumenism at a time when the Anglican Church and the non-conformist churches rarely engaged in any communion with each other. It was built by the Baptist Movement who, from their sometimes austere past, especially in the Strict and Particular Baptists sects, shunned grand ornamental churches that to them suggested idolatry. Instead, they worshipped in simple plain buildings that they called chapels. However, in this case, a dynamic group of 'modern' Baptist people believed that salvation was not exclusive to them and that all should be welcome to worship with them. The result was a church – not a chapel – built in the English Decorated style with fine stained-glass windows, which looks like any 'traditional' Anglican church in Leicester.

Moreover, the architect, John Tarring of London, made excellent use of the limited space available to create a building that looks larger and taller than it really is. Even today, the spire dominates the view south along the London Road.

The ecumenical fervour continued. As there was no Anglican church serving the neighbourhood, it was decided that the appellation 'Baptist' would not be used, not even on the noticeboards or anywhere inside the church. It was to be known simply as the Victoria Road Church, the intention being to attract those residents who would normally attend an Anglican church, as well as those of non-conformist beliefs. The choice of the first minister was an important matter. He was to be a Glaswegian Baptist who had served as minister of the important Broadmead Baptist Church in Bristol. The church also hired a professional organist to ensure that the music was up to the same standard as in Anglican churches.

The first service took place on 6 January 1867 and, in the years that followed, the congregation steadily increased. Several influential Leicester men joined the non-conformist ranks, including Edward Wood, the founder of the footwear business Freeman, Hardy and Willis, and George Stevenson, a solicitor who became Mayor of Leicester. It was a 'comfortable' conservative church; a Baptist church for Anglicans, the middle class and the fairly wealthy.

The arrival some years later of a new minister, the Revd Frederick Meyer who was young and of the more energetic evangelical tradition, caused factions to occur, which led ultimately to a breakaway group led by Meyer building their own church in the Highfields Area. This was nearby but on the opposite side of London Road. This became Melbourne Hall, another distinctive building of an entirely different style of architecture, and very much a gospel hall, not a church.

It was an unhappy time for the Victoria Road congregation. After a period of discontent, Meyer resigned and announced his intention to take up the role of pastor of a chapel in

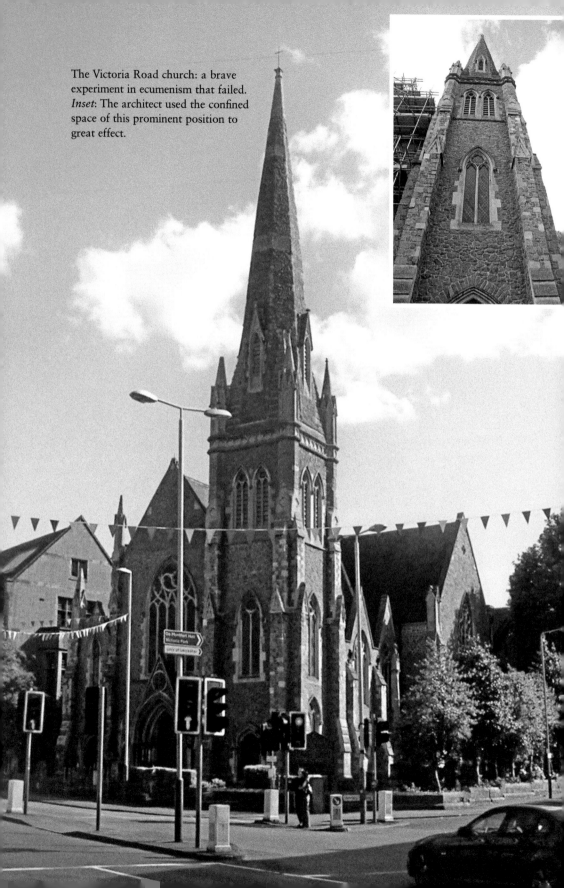

The Victoria Road church: a brave experiment in ecumenism that failed. *Inset*: The architect used the confined space of this prominent position to great effect.

Sheffield. A group of Baptists petitioned him to stay in Leicester and for a while he led services at the New Walk Museum in competition with Victoria Road. Numbers attending both places of worship declined. At the art gallery, nude statues were covered with sheets before each service, presumably so they did not cause a distraction to the worshippers. However, Meyer continued to believe that there was a future in the area for his form of dynamic evangelical preaching. In 1891, just three years after he had resigned from Victoria Road, the foundation stone of his new church, Melbourne Hall in Melbourne Road, was laid.

Melbourne Hall is still active. Despite finding itself at the centre of a suburb, in which there are many faiths and many different cultures, it has remained true to its Baptist beliefs while being able to reach out and work with those of different faiths. The Victoria Road church continued for many years, but finally closed in the last decade of the twentieth century. The building was purchased by the Seventh Day Adventist Church and is now their Leicester Central Church. It would be interesting to know how those pioneers in Leicester ecumenism who built the church would regard its new role.

## 25. The Clock Tower, 1868

In 1867, a group led by John Burton, who owned a photography business nearby, raised funds for a landmark building. The challenge was to construct 'an ornamental structure ... in height from 35 to 40 feet to contain four illuminated dials, four statuettes or medallion busts of ancient benefactors to the town, with a platform around 18 feet square, and lamps as a safeguard to passing pedestrians'.

Over 100 designs were submitted and 472 subscribers contributed a total of £872 2s 9d, with £1,200 coming from the corporation. It was built in the following year by Leicester architect Joseph Goddard, using stone from Ketton in Rutland, with a base of granite from nearby Mountsorrel. The columns are in polished Peterhead granite and serpentine. Facing outwards from the tower are statues of Portland stone depicting four 'sons' of the town: Simon de Montfort, William Wyggeston (spelt 'Wigston' on the tower), Thomas White and Gabriel Newton. It was where Leicester people would dance on New Year's Eve and would settle grievances.

It is now Grade II-listed, but in the 1930s there were demands that it should be demolished or relocated to give way to the increasing traffic. Folklore holds that this was the first traffic island in the country. However, despite rebuilding and redevelopment all around, the clock tower has survived. Even Konrad Smilgielski, Leicester's first planning officer, who proposed skyscraper blocks overlooking this junction, decided the clock tower should stay – not because he appreciated it, but because he knew how much it meant to the people of Leicester.

By the 1960s, the increase in traffic led to the area being described as 'Leicester's Piccadilly Circus'. An unconfirmed story tells of the editor of the *Leicester Mercury* facing delays in delivering the newspaper to street vendors because of the traffic and asking the Chief Constable, Robert Mark, to act. Mark, it is said, responded by inventing traffic wardens.

The clock tower was restored in 1992 by local architects Pick Everard to mark their 125th anniversary. Recently, Leicester City Council has removed unnecessary street 'furniture' and has provided new landscaping.

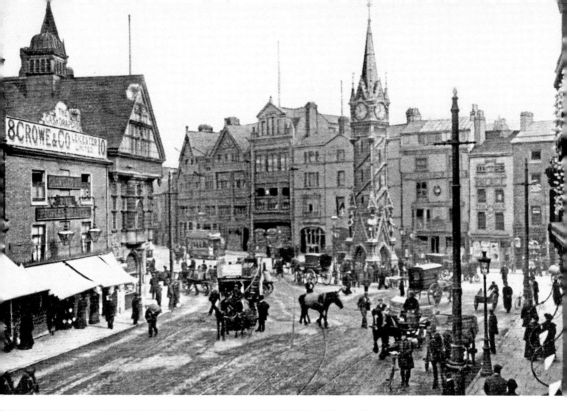

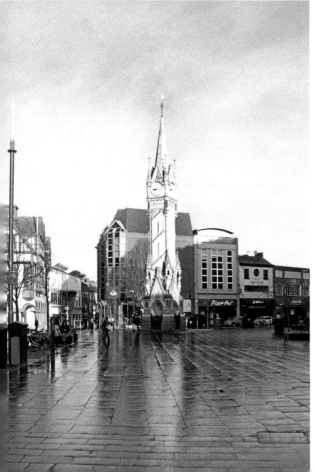

*Above*: The clock tower in winter.
An early photograph before the age of the trams.

*Left*: The clock tower as viewed from Gallowtree Gate.

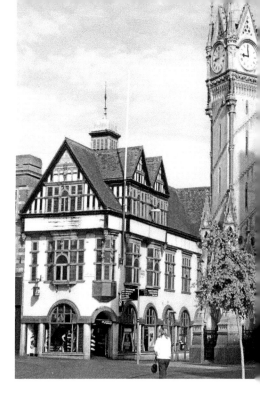

Leicester's much-loved central landmark, Joseph Goddard's clock tower of 1868.

## 26. St Mark's Belgrave Gate, 1870

Standing on the corner of Belgrave Gate and Foundry Square, this tall gaunt place of worship is Grade II-listed and a vital part of Leicester's Victorian social history. The architect was Ewan Christian, who is well known for his restoration of Southwell Cathedral and Carlisle Cathedral. However, it is St Mark's that can justly lay claim to be his masterpiece; in its style and design, the use of materials and intuitive plan, it stands out and ranks with the great churches of other more famous Victorian architects.

It was built over a period of three years from 1869 on a challenging site because its shape, which narrowed on both the north–south and east–west perspectives. This would have accommodated only a relatively small church of cruciform shape unless the building could have been 'bent' to fit the irregular shape of the land. Responding to the challenge, Christian placed the tower and spire at the south-east corner of the church and built three 'step-backs' from that point towards the west end. He also needed to disguise the angled shape of the body of the church and he achieved this very effectively by disguising the angle or 'cant' by adding two small chapels projecting from the south aisle. A similar device was used on the opposite side.

It is in the Gothic style and built of purple granite rubble with stone dressings and roofs of Swithland slate that gives the church a gaunt and dominating presence. The building was financed as a gift to the people of the area by the Herrick family of Beaumanor Hall, Woodhouse, near to the source of Swithland slate.

Today, the modern buildings around it are inconsequential, but the church was originally surrounded by large industrial buildings including foundries and textile factories, and was close to the canal wharf. Hence, in its day its powerful presence was very much in keeping with its surroundings. The church was extended in 1903 and stained glass was added in

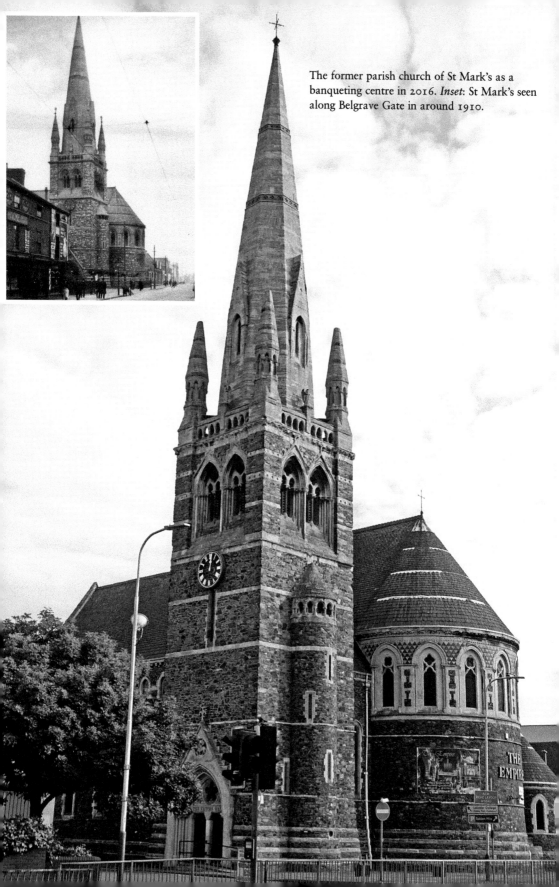

The former parish church of St Mark's as a banqueting centre in 2016. *Inset*: St Mark's seen along Belgrave Gate in around 1910.

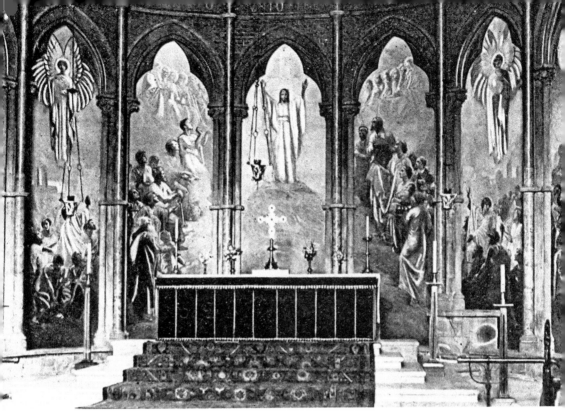

The remarkable socialist altar murals by James Eadie-Reid, still surviving but no longer visible.

1893 and 1895. However, the St Mark's is famous for one of its priests, and for remarkable altar paintings, which have survived but are now obscured by modern fittings.

The most famous priest of St Mark's was Revd F. L. Donaldson who (with Amos Sherriff, who would become Mayor of Leicester, and George 'Sticky' White, who was secretary of the Unemployed Committee and walked with the aid of a stick) was one of the leaders of the Leicester March of the Unemployed to London, which departed from the town on 4 June 1905. In Donaldson's case, the plight of the unemployed could be seen in his parish and on the doorsteps of St Mark's. The march was unsuccessful in obtaining any positive response from the government but remains a landmark event in the history of labour in Leicester. He had become vicar of St Mark's in 1896 and wrote of his parish:

> In this parish there is represented much of the tragedy and pathos, shame and horror of modern social conditions – infant mortality, child labour, underpayment or sweating of men and women, decadence of physical life, consumption and premature death.

Donaldson later became a canon at Westminster Abbey. However, his socialist Christian ideals live on in a group of dramatic painted images that are still located behind where the altar stood in the church. They were commissioned by Donaldson and created by the Scottish artist James Eadie-Reid (1859–1928). The seven sanctuary images include Jesus Christ as the Apotheosis of Labour.

Eadie-Reid was born in Dundee in 1856 and studied in Edinburgh before exhibiting at the Royal Scottish Academy and the London Salon. In his long career, he designed stained glass windows and murals for many churches in the North East and the

Midlands. At the time of the St Mark's murals, Eadie-Reid was working and living in the north-east of England, an area where he would have witnessed the poverty of the working classes of that time. There is one other painting by Eadie-Reid in Leicester at St Peter's Church in Highfields.

These remarkable murals can no longer be seen. After lying empty for several years and threatened with demolition, the church was restored and converted into a restaurant in the 1990s.

## 27. Former Midland Bank, 1874

On the corner of Granby Street and Bishop Street and built for the Leicestershire Bank and later occupied by the Midland and then HSBC banking groups, this former bank stands out from an otherwise fairly monotonous group of buildings. It was designed by a practice led by the eminent Leicester architect Joseph Goddard between 1870 and 1872 in a remarkable and well-judged blend of Gothic and oriental styles known as Venetian-Gothic.

This spectacular gothic building at No. 31 Granby Street was created in red brick and Portland stone with an unusual corner porch at the intersection of the roads and French pavilion roofs. The frontage facing Granby Street is dominant and impressive with three tall decorated windows. The stained glass in these windows is a significant feature of this historic building and have been repaired and restored.

The imposing Granby Street elevation: a 'church' in praise of wealth.

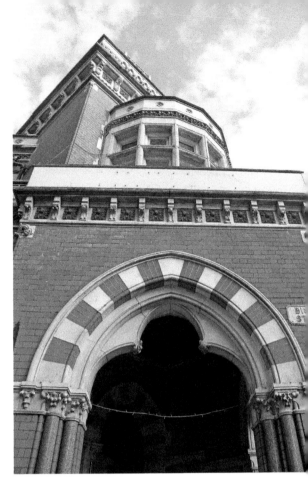

*Right*: A hint of oriental architecture in the angled entrance porch of this former bank.

*Below*: The former Midland Bank, an imposing building in which the delight is in the intricate detail.

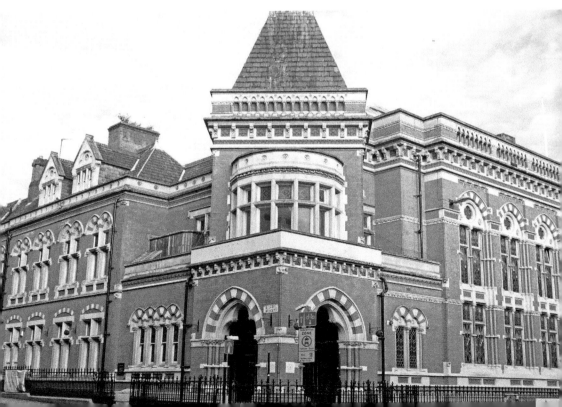

Much of the quality and charm of this building lies in its small and intricate detail. Local stonemason Samuel Barfield, who often worked for Goddard, carved numerous small 'monsters', which can be seen throughout the building.

The bank, having lain empty for several years, was donated by its owners to the International Society for Krishna Consciousness. With the assistance of a grant from the Heritage Lottery Fund, the society has been able to undertake full refurbishment. They have also received, as a gift, documents that explain the context of Joseph Goddard's original designs.

## 28. The Town Hall, 1876

Many of England's town halls are grand structures in prominent locations, designed and built to demonstrate the civic pride and economic riches of the town or city they represent, and to celebrate the democratic and legal processes that are carried out within them. Yet Leicester's town hall is easily missed because it is set away from the thoroughfares in a relatively quiet corner of the city centre.

The town hall was built on the former cattle market to replace the old Guildhall. It was designed in the Queen Anne style by the London architect Francis Hames (1850–1922) and was opened in 1876. Unlike some of its more austere counterparts, particularly in England's northern cities, Leicester's town hall has a sense of warmth and of welcome. Constructed on ground that slopes away from Bishop Street to Horsefair Street, the inclusion of a clock tower, rising to 145 feet in height at the lowest point of the building, provides subtle architectural balance.

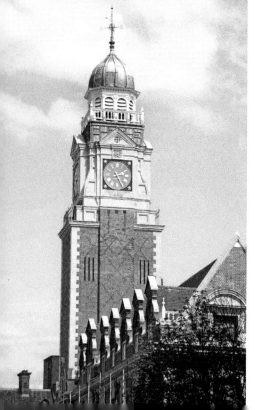

Warm and welcoming, Leicester's impressive but modest town hall.

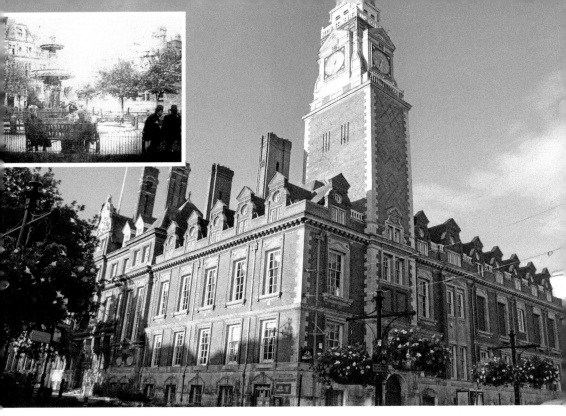

The town hall. The clock tower disguises the slope of the land on which it stands. *Inset*: A lantern slide from around 1875 showing the town hall with the famous fountain in the foreground.

The building was needed because the Guildhall, which had been used by the town administration for more than 300 years, could no longer accommodate the activities of an expanding Victorian municipal corporation. It was also designed to include the local judicial processes with court rooms, cells and retiring rooms for judges. By the 1960s, local government had expanded to such an extent that even this capacious building was proving to be too small. Much of the administration was moved to the infamous New Walk Centre, demolished by controlled explosions in 2015. Today, local government is managed from the city hall in Charles Street, built in the 1930s and in the ownership of the council.

Town Hall Square is a popular lunchtime meeting place for local workers, surrounded by Bishop Street Methodist Church and other Georgian, Victorian and Edwardian buildings of considerable dignity. The fountain in the centre of the square was donated to the town in 1878 by Sir Israel Hart, a former mayor and High Bailiff, in order to maintain the area as a public open space for all time.

## 29. St Martin's House, 1877

The first significant building on this site, by the side of the ancient high street and principal north–south route through the old town, was the hospital built with money provided by the wealthy wool merchant and Mayor of Leicester, William Wyggeston in 1518. Some of the footings of the main hospital building can still be seen in the corner of the car park facing Peacock Lane.

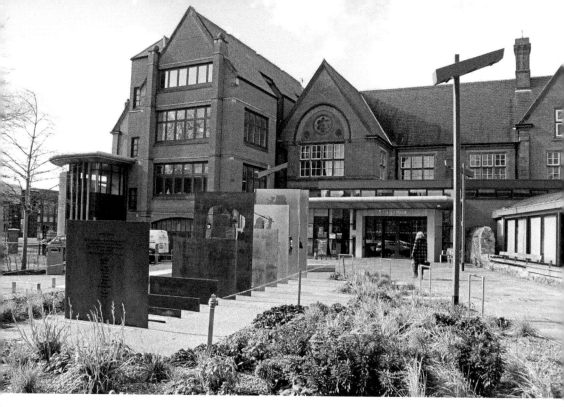

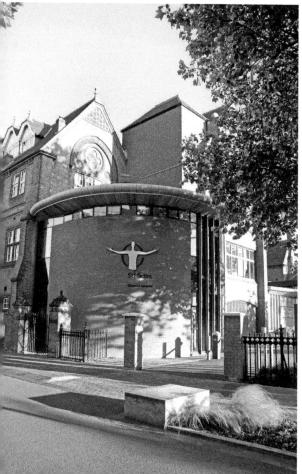

*Above*: St Martin's House, Victorian Gothic with later additions and now twenty-first century public art.

*Left*: The former Wyggeston Boys' School, now the Diocese of Leicester's St Martin's House.

This was the playground of the Wyggeston Boys' School, now an attractive approach to the new entrance lobby.

In 1874, the hospital moved to new premises and the Tudor building was demolished. It was replaced by the present structure that was erected as the Wyggeston Boys' School. In time, the Wyggeston Foundation provided new and larger premises for their school and the buildings became the home of the Alderman Newton's School. When the responsibility for education was passed to the County Council in the 1970s a reorganisation took place, and the building became redundant. However, it was finally purchased by the then newly formed Leicester Grammar School.

A further chapter in the life of these buildings commenced when Leicester Grammar School followed in the paths of the former two schools, moving to purpose-built modern premises south of the city in Great Glen. Once again, the building was put up for sale, and on this occasion was purchased by the Diocese of Leicester with the help of a substantial financial gift. After thorough but sensitive refurbishment, St Martin's House is now the centre for much of the Diocese's pastoral and administrative work, as well as being a welcoming location for wedding receptions and other events.

The discovery of the remains of Richard III nearby has led to a major refurbishment of the Cathedral precincts, which has enabled landscaping and helped to integrate St Martin's House with the churchyard and the two ancient pathways that run between Guildhall area and Peacock Lane to the west and east of the cathedral. Taken in its wider setting, with Wygston's House (opposite St Martin's House), Jubilee Square, the High Cross, and the King Richard III Visitor Centre in Greyfriars, an attractive area of heritage, history and worship has been created in this part of the old town.

## 30. Hawthorn Building, 1890–1937

The campus of De Montfort University has grown to dominate the Newarke in the twenty-first century but the buildings that represent the origins of this institution are still standing and in use.

It was born out of a desire to form a school which 'would be able to afford authoritative instruction in art to the people of Leicester'. A public meeting was called in October 1869 and, by March of the following year, the Leicester School of Art had been formed, with lessons being held in an old warehouse.

At the same time, the headmaster of the Wyggeston Boys' School in Highcross Street, Revd James Went, began a series of technical classes. To respond to the demand, this developed into the Leicester Technical School, which was founded in 1882. These two organisations merged in 1897 to form the Leicester Municipal Technical and Art School, set up by the Leicester Corporation, and an impressive new building appeared in the Newarke to house the classes – the Hawthorn Building. It was extended, with additional wings being added in 1909, 1928 and 1937, and is still in full use today. The building was named after John H. Hawthorn, the first headmaster of the newly established technical school.

The original wing of the Hawthorn Building, which faces the Newarke Gateway, was designed by Samuel Perkins Pick, who co-founded the Leicester architectural practice now known as Pick Everard. Beneath the west wing lies several arches from the Church of St Mary of the Annunciation in the Newarke, in which the body of Richard III was

Solid and stately architecture, the original wing of De Montfort University's Hawthorn Building. *Inset*: The medieval arches of the St Mary's in the Newarke, uncovered during building work in 1935.

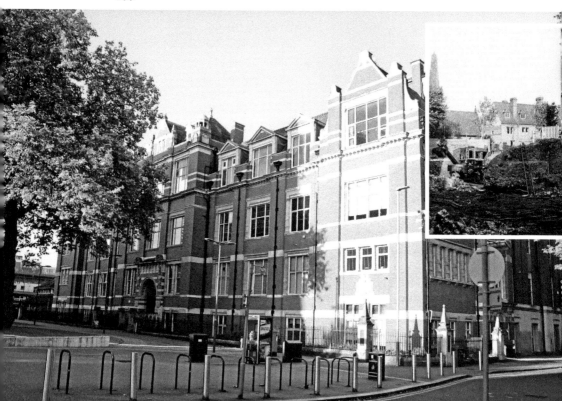

displayed for three days following the Battle of Bosworth in 1485. The church was destroyed following the Dissolution but, remarkably, the arches were preserved, having been discovered during demolition work in 1935 in preparation for the construction of the final wing. These arches now form a central feature of De Montfort University's Heritage Centre.

The Leicester Municipal Technical and Art School was renamed as the Leicester College of Arts and Crafts and the Leicester College of Technology in 1929. The college became Leicester Polytechnic in 1969, which in turn became De Montfort University in 1992.

## 31. Abbey Pumping Station, 1891

This superb example of decorated Victorian Gothic architecture, with features deserving of a grand city church, was completed in 1891 to pump the town's sewerage up to the then open fields at Beaumont Leys. The building was designed by Leicester's Stockdale Harrison. Inside are four massive compound beam engines, designed by Arthur Woolf and built by Gimson & Company of Leicester. All four engines have been restored and are in full working order. They are maintained today by experienced and skilled volunteers from the Leicester Museums Technology Association. When installed, these engines pumped

Stockdale Harrison's pumping station of 1891; a fine example of Victorian Decorated Gothic. *Inset*: The remnants of the Victorian age contrast well with the technologies of the adjacent National Space Centre.

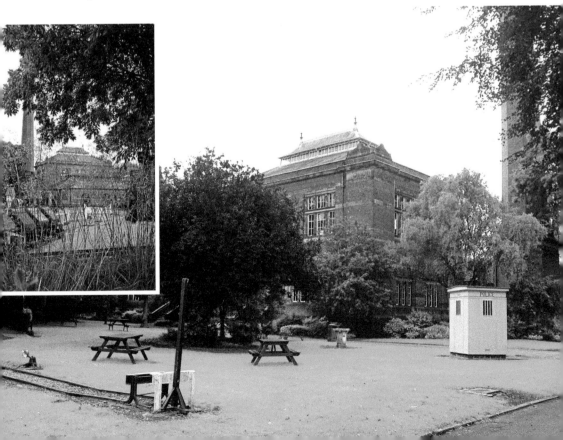

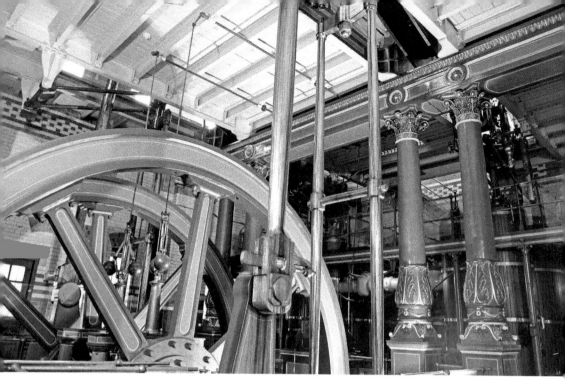

A 'cathedral' to Victorian engineering. Two of the four working beam engines.

208,000 imperial gallons of sewage an hour (263 litres per second). This is the only engine house in the world where four working examples of the same beam engine can be seen under the same roof.

The building was a major improvement in the town's sanitation, which until 1851, were almost indescribable in their paucity and effects. Railway wagons and canal barges were employed to convey the waste from open sewers. The solution at the time was to pump all the waste out of the town and into sewerage farms in the open countryside. The station continued to operate until 1964 when electric pumps were installed and soon after a modern sewerage treatment plant was built at Wanlip, north of the city. The building reopened in 1972 as a museum of science and technology run by Leicestershire Museums.

In 2015, Leicestershire County Council announced the closure of the Snibston Discovery Museum, where many of Leicester's industrial artefacts of the pasts were housed. This was an inheritance from when the museums of Leicester and Leicestershire were managed by the same authority. Their return to the city prompted a reconsideration of the facilities at the Abbey Pumping Museum and has triggered yet another new era in its eventful history.

## 32. Leicester Railway Station, 1892

The Midland Railway's first station in Leicester was located in Campbell Street off London Road, and was an impressive structure that looked more like a Greek temple. However, by the 1880s it was looking dingy and unkempt. Across the town, the dynamic Great Central Railway had constructed a rival route using cutting edge mechanical engineering, which meant a faster service to London. In response, the Midland Railway built a new station next door to their original terminus.

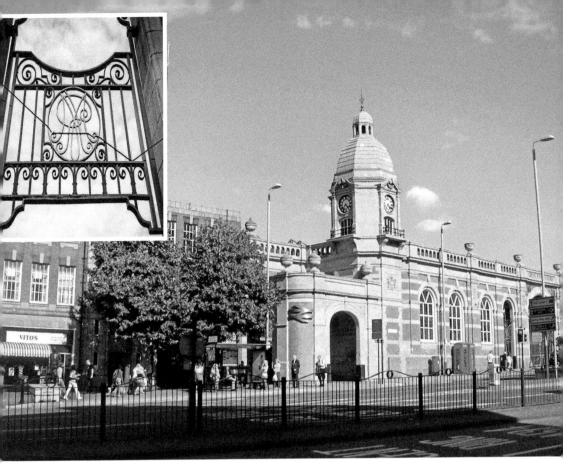

*Above*: Leicester's London Road railway station.
The turret clock is still wound by hand.
*Inset*: Fine ironwork incorporating the Midland
Railway emblem in the gates by the local Elgood
foundry.

*Right*: James Butler's statue of Thomas Cook,
standing close to where his first-ever rail excursion
departed.

It was designed by the company's architect Charles Trubshaw. The booking and parcel offices were opened in 1892, and the station was completed in 1895. Remarkably, the entire ticket operation was transferred to the new building in the space of just three hours and fifty minutes in the early hours of the morning between the departures of two trains.

The station façade has four entrances, two for arrivals and two for departures, although these are not used today. They are an example of the early integration of public transport, providing easy access for coaches and horses. The wrought-iron gates, which incorporate the motifs of the Midland Railway Company, were made in Leicester by the Elgood Foundry. George and Thomas Elgood were local topographical artists of considerable renown. In the 1970s, the frontage was threatened with demolition to make way for a road traffic scheme but was saved due to a campaign by the Leicester Civic Society.

The station clock is the only turret clock in a railway station in the UK that is still wound by hand. The first excursion, organised by Thomas Cook, departed from the Campbell Street station. A statue by James Butler RA, standing outside the entrance to the present station, commemorates the pioneer's work and was unveiled in 1991 to mark the 150th anniversary of his first excursion.

## 33. Alexandra House, 1895

Alexandra House was built as 'a Renaissance palace' for the highly successful manufacturing company of Faire Brothers. It was designed and built between 1895 and 1898 by Leicester

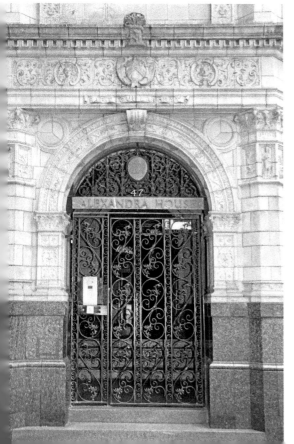

The impressive entrance to the Faire Brothers' Alexandra House, the centre of their textile empire.

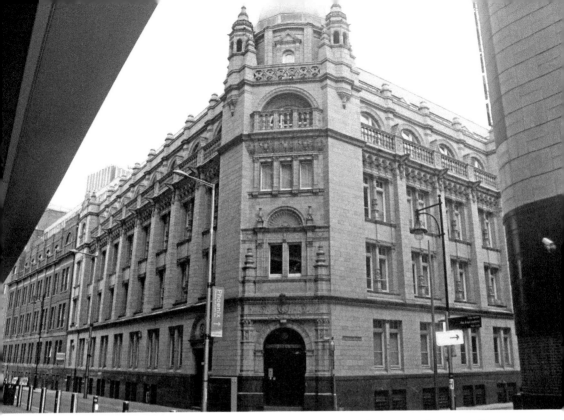

*Above*: Alexandra House, exemplifying the wealth and prosperity of Leicester's former textile industries.

*Below*: Architectural reflections: the sunlight plays on the modern Curve Theatre and the nineteenth-century Alexandra House.

architect Edward Burgess as the company's Leicester headquarters but also serving as a bootlace warehouse and elastic web factory.

It stands emphatically at the corner of Rutland Street and Southampton Street. Burgess created a building that emphasised the prestige of Faire Brothers with ornate friezes, baluster balconies and corbelled octagonal turrets and spires. Its façades are faced in ornate buff terracotta with a polished marble plinth and a wealth of fine decorative detail, including ten figures of Atlantes supporting the brackets of the main cornice. Exemplifying Burgess's eye for detail, the street sign for Southampton Street is incorporated into the brickwork.

A number of offices survive on the lower three floors, mostly decorated with wooden panelling. There were small personal offices for high-grade staff, with elaborate panelling and fireplaces, and some even included Jacobean-style plaster ceilings. The larger staff offices were plainer with painted panelling and etched glass. These, like the other spaces in this grand building, have been converted into modern apartments.

The building was damaged by bombing in 1941 but rebuilt. The exterior was fully cleaned in 1990, revealing the quality and richness of the structure. Today, Alexandra House is at the heart of the cultural quarter, its powerful presence still challenging the neighbouring buildings, even the modern Curve theatre.

## 34. Grand Hotel, 1898

Now known as the Mercure Leicester Grand Hotel and strategically located on the main London Road approach to the city from the south, near to the railway station and to Leicester's more upmarket shops and stores of the Victorian period, the Grand Hotel has always been regarded as one the most prestigious in the city.

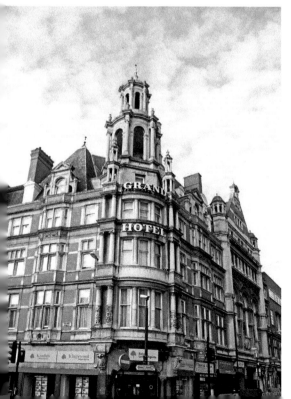

Amos Hall's 'wedding cake' corner of the Grand Hotel, influenced by Wren's London churches.

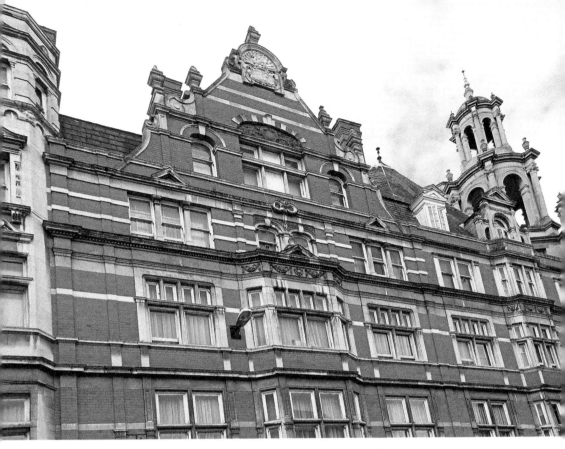

The Victorian splendour of Leicester's most respectable and luxurious hotel.

It was built between 1897 and 1898 by Cecil Ogden and Amos Hall in what has been described as a 'grand Franco-German Renaissance style reminiscent of the sixteenth century'. Hall added the 'wedding-cake' top on the corner of Granby Street and Belvoir Street two years later in a design influenced by several of Sir Christopher Wren's London churches. Hall also designed Leicester's Silver Arcade.

Although fully fitted with all of the facilities expected of a modern hotel, the elegance of late Victorian and Edwardian periods still persist. The use of internal steel frames allowed for wide windows and therefore a sense of spaciousness. The King's Hall on the first floor was originally laid out as a cinema.

Winston Churchill stayed at the Grand in 1909, and the distinguished guests at the Leicester Aero Club's annual ball in 1932 included aviator Amy Johnson and Lindsay Everard, whose funding of training for young pilots during the First World War led to the founding of the Air Training Corp.

## 35. The Turkey Café, 1901

The Turkey Café seems small in comparison with the scale of the buildings on either side of its Granby Street façade, but its physical size is more than compensated for by its flamboyant art nouveau style. It is appropriate that a café should be designed by a member of the Temperance movement, a powerful influence in Leicester at the beginning of the

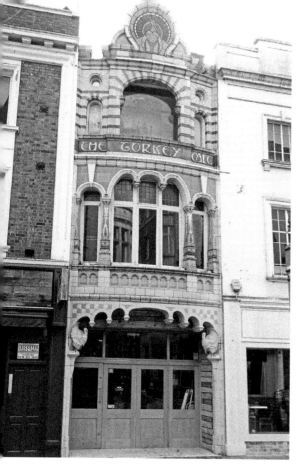

*Left*: Small but very flamboyant! Arthur Wakerley's Turkey Café of 1901.

*Below*: Gracing the top of the café's pyramidal design, a fine and characterful peacock.

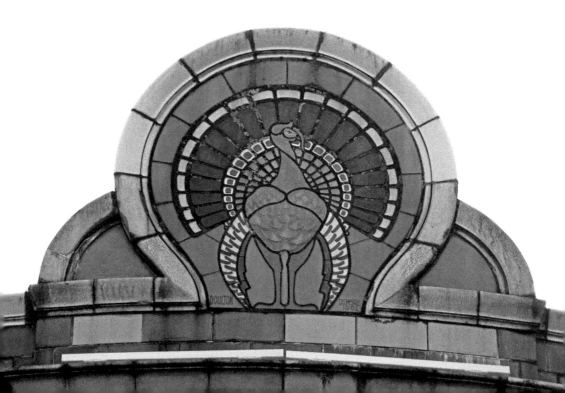

twentieth century, but its architectural style does seem somewhat surprising for a man who was also a Methodist lay preacher.

The site of the Turkey Café was owned by a Leicester grocer and sweet-maker, James Wesley. He sold the site to Wakerley and when completed the architect leased the café to John Winn, who operated a number of other cafés including the Oriental Café in Leicester. Wakerley's offices were above Winn's Oriental Café, which clearly enabled negotiations about the café to be carried out easily.

The frontage includes two puns on the meaning of 'turkey', both the bird and the vaguely 'Turkish' Eastern exotic decoration. There are three large turkey birds on the façade, one on either side of the ground-floor shopfront, and the third high up as part of a large panel of coloured Royal Doulton tiles. Doulton pioneered a particular form of tile known as 'carraware', a form of terracotta. The Turkey Café tiles were handmade by William Neatby, a ceramic artist who worked for the Doulton's company.

Wakerley created a sense of stability in this tall, slim building by using a visual pyramid form with seven arches on the ground floor, reducing in number on each storey, and completed with a single turkey at the top. The bright colours of the frontage – blue, green and buff – encouraged passers-by to stand back and appreciate its shapes and decoration.

It opened in September 1901 and became particularly popular with women, not only as a 'respectable' place for a lady to be seen in, but also as a convenient place where the matter of women's rights could be discussed. However, at the back of the café was a smoke room with a much darker décor, where men could gather. The Turkey Café became so popular that John Winn took over the adjacent building in 1911. This had been the premises of Wheeler Kendall, the umbrella merchant who founded the well-known but now defunct Kendall High Street chain.

The local ice cream and café company, Brucciani Bakers Ltd, purchased the café in 1963 where both coffee and ice cream was sold. For some years, the premises sported a 'Ladies Only' room until the 1975 Sex Discrimination Act came into force. More recently, the optician Rayners acquired the building but its original role resumed in 2014, as a café by day and a cocktail bar at night, arguably not an arrangement that the architect would have approved of.

## 36. Bishop Street Library, 1905

The municipal library, located by the side of the town hall and near the junction with Bowling Green Street, was built in 1905 with a donation of £12,000 from the industrialist and philanthropist Sir Andrew Carnegie, who also performed the opening ceremony in 1905. It was designed by local architect Edward Burgess to accommodate 40,000 books and up to 100 readers. There was a reading room for ladies on the first floor and a similar facility for 'juveniles' in the basement.

The project was very much in line with the desire of the time to encourage the 'working class labourer' to better himself by learning and education. Soon after the library opened, a series of lectures was arranged. The speakers included Ramsay MacDonald, who was then the Member of Parliament for Leicester, who spoke about 'sociology'.

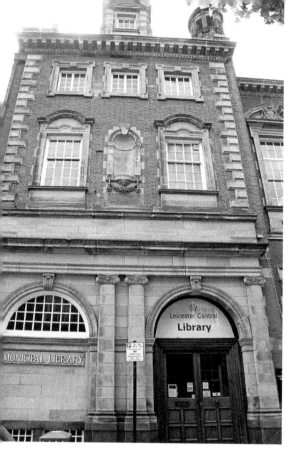

*Left*: The Municipal Library in Bishop Street. Note the blind arch next to the entrance and the first-storey niche – but no statue.

*Below*: Built with funds provided by Andrew Carnegie, the Central Library stands opposite Leicester Town Hall.

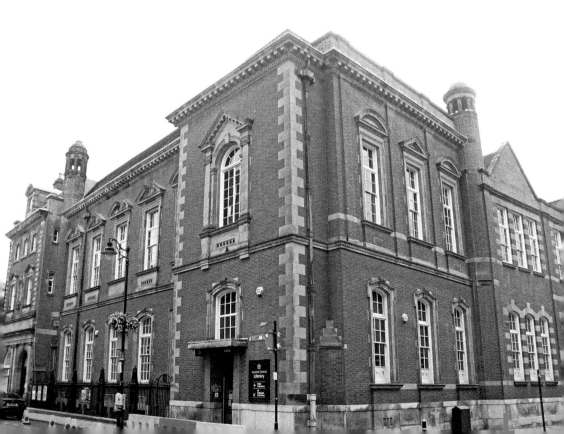

## 37. De Montfort Hall, 1913

The Leicester architectural practice founded by Stockdale Harrison provided a legacy of fine buildings, which continue to influence the character and the urban landscape of the city. One of their most successful buildings, designed by Shirley Harrison (1876–1961), son of the founder of the practice, is De Montfort Hall.

On the land of the former South Field, standing at the southern end of New Walk and near to Victoria Park and the campus of the University of Leicester, the De Montfort Hall is dignified yet modest in scale, and its classical Greek style gives it a seemingly timeless quality. At its centenary in 2013, the building looked as smart and as appropriate to the surroundings as it does in photographs taken at its completion.

A simple reason why the hall looks impressive without being aggressively dominating is because of the open green space that surrounds it. No buildings encroach upon it, which has allowed the hall to be set within a frame of green and colour. Compare this setting to all other civic buildings in Leicester, with the possible exception of the Town Hall, which has its square that serves a similar purpose. Leicester's old Victorian theatres, and even its modern ones, the Haymarket and Curve, were designed to work within cramped urban environments. The city council must be congratulated on the continuing diligence with which the flower beds and borders of the hall are maintained throughout the year.

The open setting has given the hall further benefits. There is an open-air amphitheatre on one side of the building, almost hidden from view and sheltered from the worst of the elements by the hall. The space merges comfortably with the adjacent parkland and the campus of the university, giving visitors a sense of one garden, rather than

Leicester's much-loved De Monfort Hall, its classical lines as fresh today as when built in 1913.

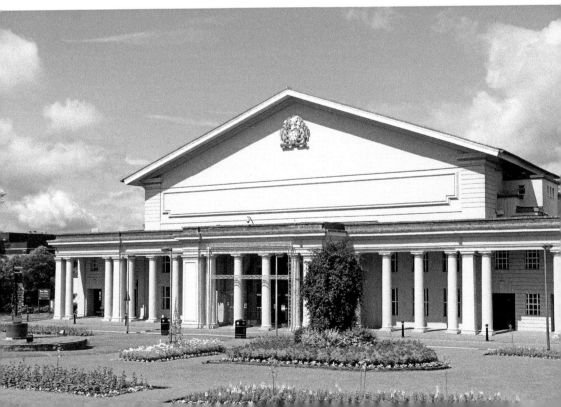

*Left*: The grounds of the De Montfort Hall include an open-air amphitheatre for music and drama performances.

*Below*: A public hall for all seasons and for all musical styles. Here, a 1970s pop group performs in front of the Victorian concert organ.

several separate structures. The space prompted the hall to stage the very successful 'Summer Sundae' outdoor festival for several years until its popularity outgrew even the Victoria Park. Furthermore, Harrison's decision to leave space available for extensions to his original design has enabled a modest addition to be built on the Regent Road side of the hall.

Although built as a concert hall, this civic amenity has proven itself able to accommodate a truly diverse range of events from school orchestras to wrestling, pop concerts to religious rallies. As well as being a venue for artists of national and international distinction, it was on the stage of the De Montfort Hall that many young people from Leicester first performed in public. It was here that a young Michael Tippett, then a pupil at Stamford Grammar School, had been 'turned on to music' by hearing the Leicester Symphony Orchestra. In the 1950s, a new generation of young musicians under the pioneering County Music Advisor, Eric Pinkett, were to form an orchestra that often performed on the stage of the De Montfort Hall, and fostered many more and smaller music ensembles and bands drawn from local schools.

In April 1953, over four days, more than 1,200 children from 120 Leicestershire schools sang and played on stage in the Leicestershire Schools Coronation Festival. The LSSO (Leicestershire Schools Symphony Orchestra) travelled across Europe during the next three decades and Sir Michael Tippett renewed his early association with Leicester by becoming the orchestra's patron and occasional guest conductor.

The lasting stature of the De Montfort Hall has been its ability to embrace the entertainment that includes and draws together all levels of society and all generations.

## 38. Pfister & Vogel Building, 1923

At Nos 78–80 Rutland Street, this fascinating building, which is now flanked by the Curve theatre, was built as the British headquarters of the American Pfister & Vogel Leather Company. Although it would look more in keeping with buildings in the company's home city, it was actually designed by the Leicester architectural partnership of Thomas Henry Fosbrooke and Waller K. Bedingfield.

However, the American influence was certainly intended as the façade is said to have resembled the company's American headquarters. Pfister & Vogel was a worldwide company based in Milwaukee. By the close of the nineteenth century, Milwaukee was the largest tanning centre in the world and the company owned the largest tannery. That Pfister & Vogel should invest in such an unusual and distinctive building in Leicester is indicative of the importance and stature of Leicester's boot and shoe industries in the mid-twentieth century.

The building was used for storage and as offices by Pfister and Vogel and by later occupiers. It was then converted into apartments, with a restaurant on the ground floor and the sub-basement level. The ground floor has since been returned to offices in the original open plan layout. The original steel columns and internal brickwork have been re-exposed and are complemented by a collection of heritage furniture and reused factory light fittings. Although not visible from Rutland Street, the building has interesting curtain-wall glazing at the back, the first such innovation in any building in the East Midlands. The restoration work gained a Leicester Civic Society award in 2008.

One of Leicester's most unusual buildings, designed locally but in an American architectural style. *Inset*: The Pfister & Vogel Building includes a wealth of fine and sublime detail. *Inset*:

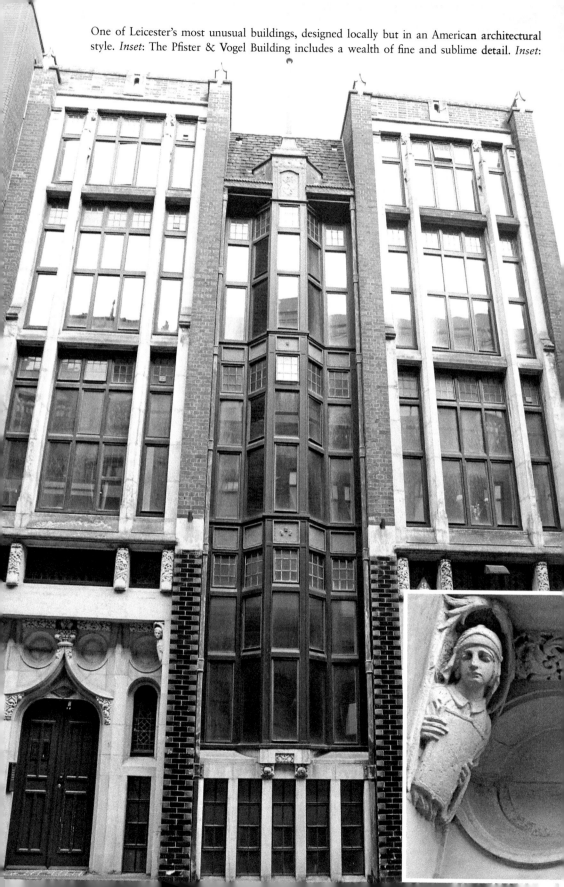

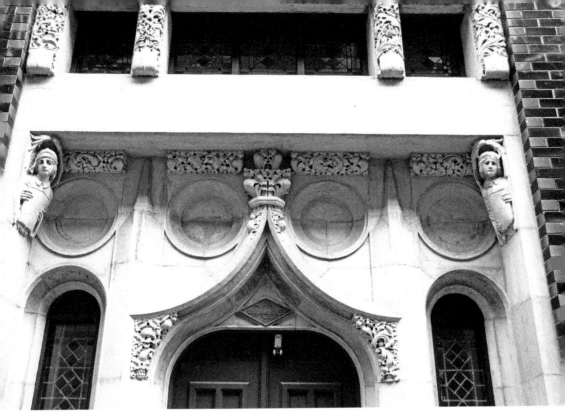

Restoration of the Pfister & Vogel Building gained an award in 2008 from the Leicester Civic Society.

## 39. Lewis's Tower, 1936

This famous local landmark is prominent on the skyline of Humberstone Gate, near to the junction with the clock tower and Gallowtree Gate. Despite being eighty years old, its modernist styling merges well with the more modern building over which it now casts its shadow.

This building is all that remains of the former Lewis's department store. Not to be confused with the modern John Lewis Partnership, this earlier chain of stores was founded by David Lewis in Liverpool in 1856.

The original store sold men and boy's clothing, expanding to sell women's clothing in 1864. The Lewis's group continue to grow and further stores opened across the country with branches in Manchester, Birmingham, Sheffield and Leicester. The Leicester store was built in 1936.

The company went into administration in 1991 but continued trading in Leicester under a management buyout for a further two years. Soon after closure, the entire building, except for the iconic tower, was demolished to make way for the modern shops that are seen today, which includes a large extension to the earlier Marks & Spencer store facing Gallowtree Gate.

The tower was designed as a receiving point for radio transmissions from the 'mother' store in Liverpool. Each day before the stores opened to the public, the management in Liverpool would speak 'live' to the shop assistants on the shop floors across the country.

The clean, plain lines of the Lewis's tower harmonise so well with the shopping complex built sixty years later.

## 40. Attenborough House, 1938

Attenborough House was built by Barnish and Silcock in 1938 as new municipal offices for the Leicester Corporation. The four-storey art deco building, standing on the curve of Charles Street, exemplified the confidence of the city of Leicester in the interwar period. Charles Street had itself been constructed in the previous decade as a broad thoroughfare, bypassing the congested streets leading to and from the clock tower.

By the 1970s, the expansion of the work of local government necessitated more accommodation for the staff and officers of the council. In 1975, the controversial decision was taken to acquire the New Walk Centre, an empty two-tower office complex that had been built as an investment venture but had failed to find a buyer. Ironically, the building's underlying concrete structure was found to be in a dangerous state, and it was demolished by controlled explosions in 2015. The City Council had retained ownership of Attenborough House to which it returned after major renovation.

Willmott Dixon restored and refurbished the building in a combined project, which involved renovating a further council-owned building, Bosworth House, to provide more accommodation. The Attenborough House work included the sensitive restoration of the original art deco features as well as the creation of new committee and function rooms.

The former Rates Hall, where residents would pay their taxes before the era of direct transfer of money, was transformed into a further function room that can now be hired out to the public. The project included significant survey and investigation work because there was some uncertainty about the structural condition of the building and none of the

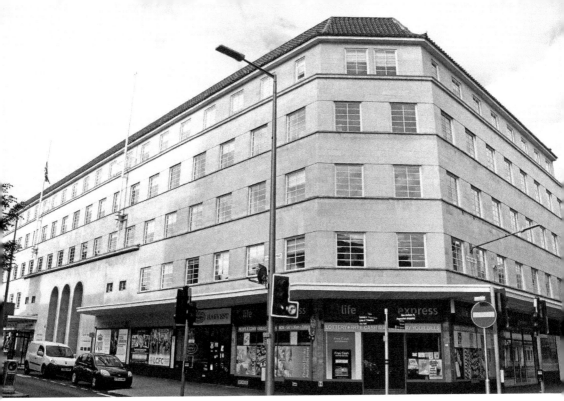

*Above*: Away from the congested city centre, Charles Street, and buildings such as Attenborough House, represented the 'modern Leicester' of the 1930s.

*Right*: The tall and slender art deco entrance to Leicester's City Hall, built in 1938.

original architect's drawings could be found. A new handrail was installed but artificially aged to give it the patina of a 1930s finish.

During the Cold War period, the corporation's nuclear bunker and control centre was located beneath Attenborough House in underground rooms. Access was from the lane running along the rear of the building. Occasionally, after the Cold War threat had decreased, the rooms were open to the public, who were offered free tours.

## 41. St Aidan's, New Parks, 1959

At the heart of Leicester's largest post-war housing estates, the parish church of St Aidan is a remarkable and special building. The architect was Sir Basil Spence and the foundation stone was laid in 1958, two years after that of Spence's Coventry Cathedral. It was completed in 1959.

The front of the church, which faces New Parks Boulevard, is in the form of a very large mural, depicting the life of St Aidan, and is regarded as one of the best-surviving tiled murals of the post-war period. It was the first major tile commission for William Gordon, who had previously produced studio pottery for the Walton Pottery in Chesterfield, Derbyshire.

The church serves a very large parish and is well attended. The interior fittings are carefully maintained, creating a true sense of peace and beauty. Spence's skeletal concrete bell tower is one of the most significant architectural elements of this building. A comparison has been made, by some visitors, with the tower of the nearby fire station.

Is it a church? Sir Basil Spence's fascinating parish church of St Aidan, completed in 1959.

*Right*: The glory of St Aidan's, the impressive tiled mural by William Gordon, that tells the life of the saint.

*Below*: The formal lines of the quadrangle of St Aidan's and the stark skeletal footings of the bell tower.

## 42. Lee Circle Car Park, 1961

The Lee Circle car park opened in December 1961 and is the oldest multistorey car park in Europe. It was built as part of Leicester's post-war slum clearance programme of the Wharf Street area, which was never completed, leaving the area without character or focus. When constructed, its dark and grey outline was totally out of scale and was unsympathetic with surrounding buildings such as the Victorian British Steam Specialities factory.

Although not a building that can be described as attractive, it is a structure of considerable complexity, having two entrances at ground level, one at either end, and an interleaved spiral or double-helix rising to each floor. It is also difficult from certain angles to visualise how these spirals are supported, and it can be very confusing for car owners who may have forgotten on which spiral their vehicle has been parked.

Beneath the car parking levels, the supermarket chain Tesco opened their first retail operation outside London. For some years it held the distinction of being the largest store by floor area in Europe. Integrated with the car park above, the shop staff would bring shoppers' purchases directly to the customers' cars. This innovation was regarded so newsworthy that British Pathé filmed a newsreel featuring the car park and store and reported the innovation nationwide.

The Lee Circle car park when completed in 1961 with a Tesco store on the ground floor and a petrol station next door. *Inset*: Uninviting, cold and grey. A largely disliked Leicester landmark but a significant example of 1960s design concepts.

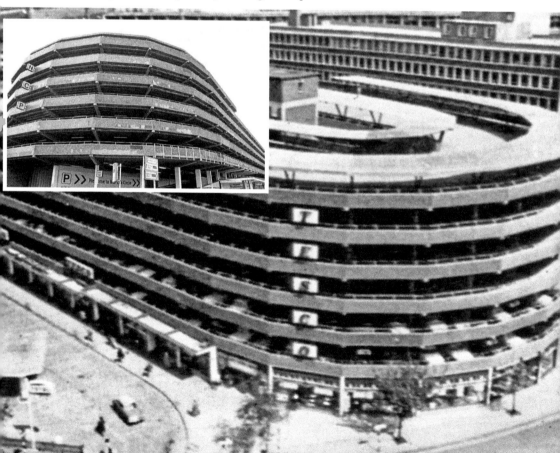

## 43. Stirling and Gowan Building, 1963

Architecturally, the most exciting of the three towers on the University of Leicester campus is the Stirling and Gowan building, which has promoted enthusiastic and detailed comment from architects across the world. With its high-rise neighbours, the Charles Wilson Building and the Attenborough Building, it provides a familiar backdrop to Victoria Park as seen from the London Road.

It was completed in 1963 and is regarded as the finest work from the Stirling and Gowan partnership. To some admirers, the building defies description, presenting a different set of lines, light and angles from each perspective chosen by the viewer. Its design at the drawing-board stage was based on axonometric projections, which enabled the architects to 'see' the tower three-dimensionally from many different angles. It has influenced the design of similar structures not only in the UK but as far away as Japan. However, some who have worked in the building and lived with it feel that it wastes space and is uncomfortable as a work environment.

James Stirling and James Gowan worked together for just seven years from 1956 to 1963. This building therefore represents one of their final collaborations. In 2015, renovation work costing more than £19 million commenced to ensure the future of this iconic Leicester landmark.

*Below left*: The Stirling and Gowan Building provides an almost stately backdrop to this part of Victoria Park.

*Below right*: At night, the Stirling and Gowan Building is a tower of light overlooking the University of Leicester campus.

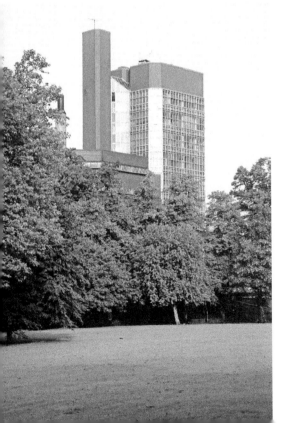
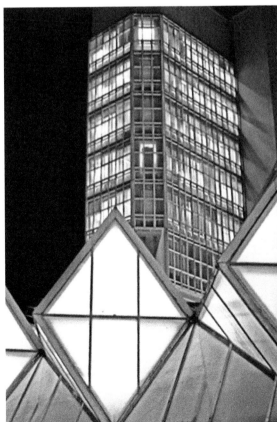

Many different angles, levels and visual deceptions combine to make this one of Leicester's most talked-about structures.

## 44. Haymarket Theatre, 1973

All of the buildings in the entire area between the Haymarket, Belgrave Gate and Humberstone Gate, including many from the Victorian period and earlier, were demolished in the early 1970s to make way for the Haymarket Shopping Centre, which now occupies a triangle extending outwards from the clock tower. As part of this development, Leicester acquired a new theatre, which, within a few years, achieved national acclaim. Many productions that premiered at the Haymarket Theatre moved on to London's West End and even to Broadway.

The theatre opened in 1973 with the official ceremony being presided over by Sir Ralph Richardson. It had been designed by Stephen George and Dick Bryant from Leicester City Council's architect's department, who had also designed the smaller and 'temporary' Phoenix Theatre. The Haymarket was both an attractive and unusual building and, in many of its design features, was far ahead of its time.

From its first season, the Haymarket Theatre attracted creative people of imagination and skill. In its first season, theatre-goers were able to see *The Recruiting Officer*, the classic comedy play from 1706 by the Irish writer George Farquhar; *Economic Necessity*, a new play in 1973 by John Hopkins; and starring Anthony Bate, and the musical *Cabaret*.

Two of the theatre's first production directors were Robin Midgeley and Michael Bogdanov and, for many years, Robert Mandell was the musical director, masterminding a string of immensely successful musicals, many of which later moved to London and to Broadway. These included *Joseph and the Amazing Technicolour Dreamcoat*;

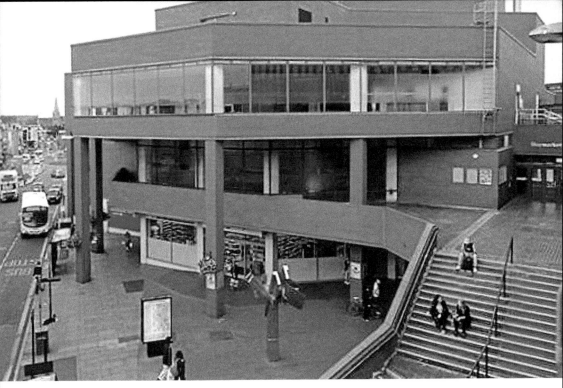

*Above*: Welcoming yet distinctively modern, the Haymarket Theatre was a highly innovative and imaginative building.

*Below*: The spires of Leicester Cathedral and St Mary de Castro overlook the topping-out of the Haymarket fly tower in 1973.

*The Boyfriend*, which included the late Miriam Karlin and a young Elaine Page in the cast; *Oliver!*, starring Roy Hudd as Fagin; *My Fair Lady*; and *Oklahoma*. Born in New York, Mandell had worked under Leonard Bernstein, and moved to London in 1972 as the musical director for the Anthony Newley and Leslie Bricusse musical *The Good Old Bad Old Days*, which ran for 309 performances at the Prince of Wales Theatre. His flamboyant style and personality brought vigour and enthusiasm to the new theatre in Leicester.

When Leicester's new theatre, Curve, opened in 2008, the Haymarket closed and has been silent ever since, but in 2015 a local consortium was formed to reopen the building and use it for community art projects. The theatre is still owned by Leicester City Council and was therefore maintained during its years of darkness. An innovative building, it is arguably the best element within an otherwise mundane shopping development. Having brought life, fun and entertainment to so many local people, the Haymarket deserves a new purpose and an assured future.

## 45. Our Lady of Good Counsel, 1975

A church of modest size standing in a quiet suburban housing estate, Our Lady of Good Counsel was designed by Reynolds and Scott for the Roman Catholic Diocese of Nottingham. This little-known architectural practice produced a considerable number of Roman Catholic churches, mostly of plain and sometimes stark design. The lack of recognition for their work stems partly from the firm's apparent disinterest in discussing or publishing their work. Several of their churches became listed, but only because of a mistaken belief that the company was associated with the more famous and eminent architect Sir Giles Gilbert Scott.

An intriguing variation on the traditional 'nave and tower' design, the roof line merging the two elements. *Inset*: Our Lady of Good Counsel, undeniably 'modern' but perfectly in scale and in keeping with its housing estate location.

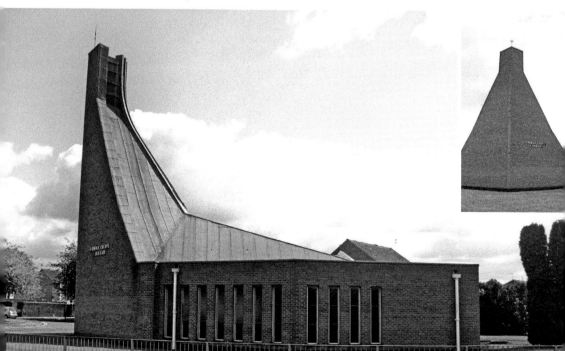

F. M. Reynolds came from an earlier partnership in Manchester to form an architectural practice with William Alphonsus Scott, also based in Manchester. It is said that he was influenced by the Arts and Crafts movement and by early Irish Christian and Byzantine architecture, but little of this can be seen in the churches that his partnership produced.

However, Our Lady of Good Counsel in Gleneagles Avenue on the corner of Peebles Way is an exception and unlike any other Reynolds and Scott church. Undeniably modernist in shape and structure, the building is designed in a radial form. From the exterior, it appears to have a traditional nave roof curving up to a tower that soars heavenwards. Inside, the visual perspective of the altar is emphasised by the organ pipes above, which appear suspended in mid-air. There is also a touch of practicality in the design that allows the Lady Chapel to be entered and used separately from the main area of worship, thus providing the estate with a convenient and flexible community hall.

## 46. National Space Centre, 2001

The National Space Centre grew out of a partnership between the University of Leicester's Space Research Centre and local government agencies. It cost £52 million, of which half came from a grant from the Millennium Commission. The centre was designed by Sir Nicholas Grimshaw who also created London's Waterloo International rail terminus and the Eden Project in Cornwall. The dramatic tower, a landmark that is visible from most approaches to Leicester, is 42 metres in height. It was made from pillows of ethylene tetrafluoroethylene copolymer (ETFE), a strong, transparent, lightweight plastic.

The dramatic semi-transparent tower of the National Space Centre, made of lightweight plastic, which can be seen on the city skyline from far afield.

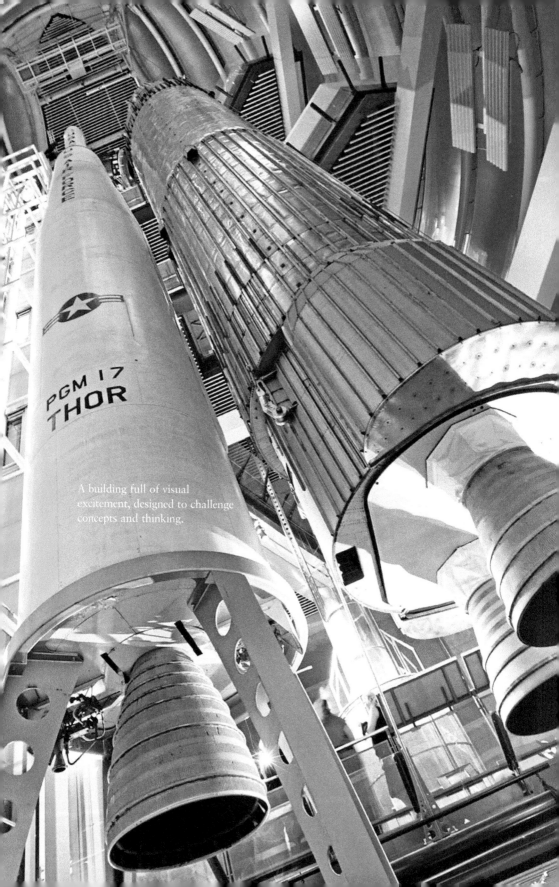

A building full of visual excitement, designed to challenge concepts and thinking.

Already a popular pose for a selfie, the statue is of US astronaut Ed White walking in space on 3 June 1965 during the Gemini 4 mission.

*The Pioneer*, a statue outside the entrance, by Aden Hynes, was commissioned to mark the centre's tenth anniversary in 2011. It shows American astronaut Ed White (1930–67) walking in space on 3 June 1965 during the Gemini 4 mission. White later died in a launch pad fire while training for the Apollo 1 mission. The centre has six main galleries of exhibits and visitor activities covering space flight, astronomy and cosmology, including one of a very few existing Soyuz spacecraft in Western Europe. The attractions also include a cinema, planetarium, gift shop and restaurant located beneath the two nozzles of a Blue Streak and PGM-17 Thor rockets.

Owing to its association with the University of Leicester, whose Astrophysics Department has been leading worldwide research for several decades, the National Space Centre Leicester plays a significant role in current space research and exploration. The adventurous but failed Eagle 2 Mars project was controlled from here, and the UK's official Near Earth Object Information Centre, linked to an observatory in the Welsh Marches where there is less light pollution, is also based at the centre.

The Apollo astronaut Buzz Aldrin was a visitor to the centre in 2005 and the first-ever Star Wars Day was held here in 2005. More recently, the National Space Centre hosted a tour by a NASA space crew, including the UK-born astronaut Piers Sellers.

There is an attractive architectural juxtaposition between the modern structures of the space centre and the red-brick façades of the adjacent Abbey Pumping Station; both buildings housing important and pioneering technologies of their time.

## 47. King Power Stadium, 2002

The story of Leicester City Football Club's climb to the top of the Premiership League is reflected in the 'rags to riches' move from their former ground at Filbert Street, the club's home since 1891, to the nearby King Power Stadium.

Apart from the Carling Stand, most of the Filbert Street ground remained as it had been since the 1920s. Former manager Martin O'Neill once joked that he would lead new signings out of the tunnel backwards so they only saw the Carling Stand.

Plans for a new stadium were formulated in 1998 but abandoned. A second plan was proposed in November 2000 for a 32,000 seat stadium near Freeman's Wharf, land adjacent to the Filbert Street ground. Work commenced in the summer of 2001 and the new stadium was completed on time, twelve months later. The opening was somewhat marred by Leicester City's relegation from the Premier League, which had caused the club to accrue debts of over £30 million. The stadium was opened officially by former Leicester striker Gary Lineker on 23 July 2002.

The stadium cost £37 million. This, combined with relegation from the Premiership, the collapse of the English transfer market because of the introduction of the transfer window and the collapse of ITV Digital Terrestrial Television, forced the club into receivership. Birse Construction, who had built the stadium, lost a large part of their fee and withdrew from any further football ground construction.

As part of the deal that brought the club out of receivership, the stadium was acquired as an investment by an American academic retirement fund, but it was sold on to the present owners of Leicester City, Thailand-based King Power in March 2013. Following the club's remarkable success in the 2015/16 season, King Power announced the expansion of the stadium to accommodate up to 42,000 seats.

The now internationally recognised 'fox' emblem of LCFC incorporating the city's heraldry.

Blue is the colour, even down to the bollards!
Celebrating Leicester City's dramatic Premier
League win in the 2015/16 football season.

## 48. Curve, 2008

Leicester is not renowned for large or impressive buildings, but Curve is a welcome
exception. It was designed by Rafael Vinoly and was described by the architects as an
'inside-out' building, their first completed project in the UK.

Vinoly defined the design as being 'innovative and democratic', respecting the industrial
history of Leicester but helping to redefine its future. It cost £61 million to complete, which
was well in excess of the original budget. The 'inside-out' concept means that every aspect
of the backstage work of the theatre remains in the public eye. There is nothing hidden.
Rather than destroying the magic and mystique of theatre, this opportunity to see first-hand
all the skills and activities that combine to make theatre, enhances the total experience.

It is also a theatre in the round because visitors can walk right round the building on the
inside, enjoying its several levels and the vast amount of glass, which seems to hang above
the ground with little or no support. The curved façade was made from 1,192 tonnes of steel
and 46,000 square metres of glass. It houses a main auditorium with 750 seats, a studio
theatre accommodating an audience of up to 350 and full production and administrative
facilities: cafes, display areas, exhibition space and cloakroom facilities. It was opened in
2008 by Her Majesty the Queen.

Of the many successful and truly innovative productions that have been staged in the
first seven years of its life, two stand out as having real resonance with the city, and both
were from the 2015 season: Shakespeare's *Richard III*, and Sue Townsend's *The Secret
Diary of Adrian Mole aged 13 3/4: The Musical*. Curve can rightly be regarded as the
fostering influence for several other activities in the Cultural Quarter.

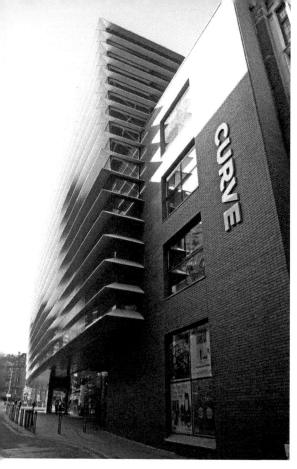

*Left*: Curve, Leicester's newest theatre, an exciting special experience both on and off the stage.

*Below*: The theatre was planned as a catalyst for further creative images and art forms within the Cultural Quarter.

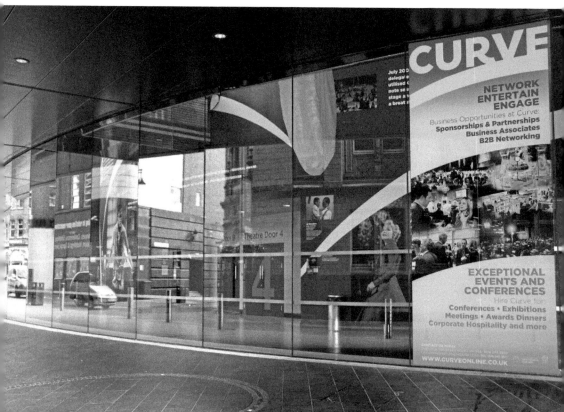

## 49. Cinema de Lux and John Lewis, 2008

Leicester's first large-scale shopping precinct was the Shires complex, which was completed in 1991 north of the High Street. The new structure retained the Victorian and Edwardian frontages. The centre was extended in 2008 and renamed the Highcross Centre. The name is taken from Highcross Street, which was the main medieval route through Leicester from north to south, and the east-west route (the modern High Street) at the High Cross where an ancient market was held for many centuries.

The two most impressive elements of the Highcross Centre are the Showcase Cinema de Lux and the John Lewis department store, which faces the section of the central ring road known as Vaughan Way.

These buildings marked the UK debut of the architecture firm Foreign Office Architects. The cinema is covered in a slightly buckled, stainless steel cladding, while the department store features two layers of glass, each with a swirling fabric design from John Lewis's archives, allowing light in and a view out, but obscuring the interior from the outside. The use of a fabric pattern recognises Leicester's past as a prominent textile-producing city.

Foreign Office Associates was the husband and wife team of Farshid Moussavi and Alejandro Zaera-Polo, who were based in London and established their company in 1993. The break-up of their marriage in 2009 resulted in the winding-up of their architectural partnership, but both individuals continue to work in the same field within separate companies.

Their designs for Leicester drew upon their international experience and reputation, and in many ways broke the accepted rules. Almost all department stores require many

The John Lewis store as seen from Causeway Lane. *Inset*: A visual experience inside and out for the Cinema de Lux façade of the Highcross Centre.

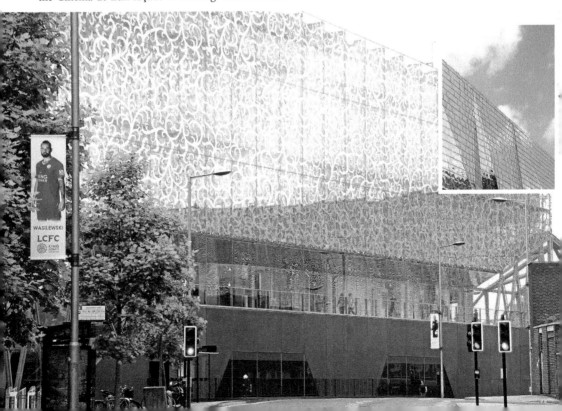

windows in which their products can be displayed. In the case of the Leicester John Lewis store, the company's reputation for fabrics and textiles is represented by covering the entire exterior with semi-transparent façades which appear to drape the building. They act as a giant screen reflecting the light and the movement of the traffic below, the sunlight and the passing clouds. In the evening, this vast curtain glows with various colours projected from inside. As part of the engineering aspects of the design, this same artistic façade also hides the air ducts and other machinery required of a large department store.

## 50. Fletcher Buildings, 2016

In 1966, the new high-rise Fletcher building in the Newarke was opened by the Queen Mother, and in that same year a White Paper plan for Polytechnics and Other Colleges was published. On 1 April 1969, the Leicester Regional College of Art and Technology, which, as two separate colleges, had a history that reached back to the 1880s, became the City of Leicester Polytechnic. It was located on two sites: the Newarke, in the heart of the Leicester, and Scraptoft on the outskirts, which had formerly served as a teacher-training college.

In the summer of 2015, the redevelopment of De Montfort University's Fletcher Buildings was still in progress. The main tower, known as Fletcher High Rise, was complete, but demolition of the Fletcher Low Rise suite of buildings, which occupied the area around

*Below left*: Fletcher High Rise on the De Montfort University campus nearing completion of its major refurbishment.

*Below right*: The same view when the Fletcher buildings were first opened by the Queen Mother in 1966.

New student accommodation and departmental buildings occupy the riverside of the Newarke in July 2016.

the tower block like concrete cloisters, was yet to commence. The new complex will house the departments of art, architecture and design, fashion and textiles. The centre will also contain the new home for the DMU Confucius Institute, which will promote Chinese language and culture.

The original buildings were named in honour of Benjamin Fletcher, the pioneering head of the Leicester School of Art from which grew Leicester Polytechnic and ultimately De Montfort University. Fletcher was instrumental in the setting-up of Dryad, the major supplier of handicraft equipment and materials to UK schools for many decades. He was also a leading influence in the evolving Arts and Crafts movement.

This development represents the largest investment yet undertaken by De Montfort University and the biggest physical development of the Newarke area since the earliest days of Leicester Polytechnic. Although the scale has prompted some criticism, the university's ongoing renewal of their buildings has created a dramatic and exciting new skyline and a campus rich in architecture, from the new Fletcher building back to the Turret Gateway of 1422 – almost 600 years of landmark buildings.

# About the Author

After a career with the BBC, during which he worked as a Studio Manager in BBC Broadcasting House and with the BBC World Service, later joining the management team at BBC Radio Leicester, Stephen Butt now enjoys writing, historical research and photography.

He has twenty books in print, which combine an academic background in local history with a practical interest in photography. Stephen's BA degree was in Psychology (University of Durham) and his MA degree is in English Local History (University of Nottingham).

During 2009–10, Stephen provided production and location research support for Michael Wood's major television series *Story of England* by organising the 'Kibworth Dig', which was a central linking theme in the programmes. He also worked on Mayavision International's *Great British Story: A People's History*, which was broadcast on BBC2 and BBC4 in summer 2012. He has also co-produced several short corporate videos for Harborough District Council.

Stephen holds the Certificate in Local Government Administration and is the parish clerk to Kibworth Beauchamp Parish Council. He is also the editor of the magazine and newsletter of the Leicestershire Archaeological and Historical Society.